CONSTABLE

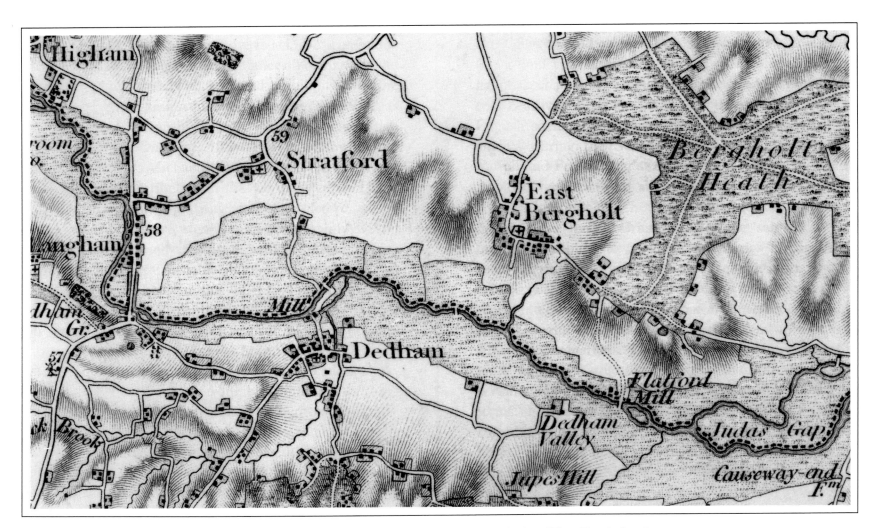

Constable Country: map of the border between Essex and Suffolk showing Dedham, Flatford and East Bergholt, 1805.

CONSTABLE

Barry Venning

STUDIO EDITIONS

LONDON

Published by Studio Editions Ltd.
Princess House, 50 Eastcastle Street,
London W1N 7AP, England

Copyright © 1990 Studio Editions

The rights of Barry Venning to be identified as author of this work has been
asserted by him in accordance with the Copyright, Designs and Patents Act,
1988.

ISBN 1 85170 427 2

Printed and bound in Hong Kong

INTRODUCTION

John Constable is arguably the best-loved of English artists; his fame and popularity are rivalled only by those of his great contemporary, J. M. W. Turner. But like Turner, his reputation rests on a handful of very well-known paintings, normally Suffolk scenes such as *Flatford Mill* (p. 83) or the *Hay-Wain* (p. 93). The latter in particular is so famous that it sometimes overshadows the rest of his work, whereas we know from Constable's writings that he set greater store by his *Stratford Mill* (for which his study is on p. 61), and once declared that it was *Salisbury Cathedral, from the Meadows* (p. 127) rather than the *Hay-Wain* which best embodied 'the full compass' of his art. For all its fame, even the *Hay-Wain* itself is misunderstood. It is so familiar that it is hard for a modern spectator to grasp the enormous impact it had upon some of the greatest French painters of the day. In order fully to appreciate Constable's achievement one must first attempt to clear away some of the many misconceptions surrounding his work.

He was, for example, a more versatile artist than most of his modern admirers realize. It is true that he was deeply and sentimentally attached to the scenery of Suffolk, and unlike many of his colleagues he did not normally tour in search of material; but his friendships and family life forced him to travel and so there is diversity in his subject matter, embracing the Lake District, Hampstead, Kent, Dorset, Sussex and Salisbury. Many of the magisterial productions of his last years, including *Hadleigh Castle* (p. 119) and *The Opening of Waterloo Bridge* (p. 131) are a far cry from the Suffolk scenes, whilst his accomplishments within the difficult and competitive genre of marine painting have been consistently undervalued.

A persistent error surrounding Constable's work is that it is somehow 'artless' and untouched by theory — that he simply 'painted what he saw' in response to the beauty of the English countryside. On the contrary, he was a sophisticated, reflective artist whose naturalism was hard-won, based on an incessant study of nature, the Old Masters and wide reading. Far from disdaining theory, Constable's library is known to have contained an enormous body of theoretical texts, ranging from classic writings by Cennino Cennini, Leonardo, Roger de Piles and Gérard de Lairesse, to the more recent works of Sir Joshua Reynolds and Henry Fuseli. Where landscape was concerned there were few important books that escaped his notice, and he had a thorough mastery of the aesthetic debates which preoccupied his contemporaries. Late in life he even lectured on the subject himself. He was also well versed in science, poetry, history and divinity, and like Turner, he put this fund of self-acquired knowledge to use in his paintings. In short, the breadth of his intelligence and the clarity of his ideas are seriously at odds with the view of Constable as a naïve realist.

It is also tempting to forget that Constable was a professional painter, and that the kind of success and reputation he desired could only be achieved in London within the orbit of the Royal Academy. He could have earned a living in Suffolk, just as his contemporary, John Crome, was able to do in Norwich; but Crome relied for a steady income upon his work as a drawing master whereas Constable looked for a professional status that would match his family's social position. Crome, after all, was the son of a journeyman weaver who kept an alehouse, and had served his apprenticeship with a coach and sign painter.

Constable had a very high-minded view of landscape and was single-minded in pursuing his own course, but he also craved recognition and tried various strategies to secure it: he increased the scale of his pictures,

occasionally varied his subjects and sometimes tailored his paintings to meet the expectations of the Royal Academy. He had an independent income but it was not enough to support his family, and he was therefore sometimes compelled to sell duplicates of his most successful scenes (p. 91) and to accept uncongenial commissions. These conflicts between his declared intentions, professional ambitions and family responsibilities are fundamental to an understanding of Constable's career.

EARLY LIFE

John Constable was born in East Bergholt, Suffolk, on 11 June 1776, the fourth child and second son of Ann and Golding Constable. His father was a prosperous local corn merchant who inherited his business from an uncle in 1764, including the tenancy of Flatford Mill, two vessels, a wharf at Mistley for corn, a coal-yard at Brantham and good arable farmland. Corn ground at the mill was carried down the River Stour in barges as far as the estuary, and from there transported to London; on the return journey they imported coal and other products to maximize Golding's income. These prosaic facts are significant, for his family's business interests provided Constable with the allowance which supplemented his meagre income as a painter, and, equally important, with a repertoire of familiar subjects.

'Constable Country', as it is now known, comprises only about twelve square miles of the Stour Valley on the Suffolk-Essex border (frontispiece). Around 1833, in a text intended to accompany an engraving of the house in which he was born (p. 38), he described East Bergholt as 'pleasantly situated in the most cultivated part of Suffolk, on a part which overlooks the fertile valley of the Stour ... The beauty of the surrounding scenery, the gentle declivities, the luxuriant meadow flats sprinkled with flocks and herds, and well cultivated uplands, the woods and rivers, the numerous scattered villages and churches, with farms and picturesque cottages, all impart to this particular spot an amenity and elegance hardly anywhere else to be found.' But, as he also confessed, the landscape evoked memories for him that his audience could not share: it had witnessed 'the happy years of the morning of his life,' and later, as he grew to maturity, it became the place where 'he early met those, by whose valuable and encouraging friendship he was invited to pursue his first youthful wish' to become a painter. He believed that the landscape, its beauties and its associations with his 'careless boyhood', had made him a painter. As if to emphasize his point, Constable introduced into the engraving of his parents' house an artist sketching in the open air.

Constable became increasingly nostalgic for his 'careless boyhood' as his anxieties and responsibilities grew, but by all accounts his early years do seem, apart from a brief, miserable interlude at school in Lavenham, to have been almost idyllic. He received most of his education at Dedham Grammar School, where according to his biographer, C. R. Leslie, he distinguished himself more by his draughtsmanship than his scholarship. His father probably intended him to become a clergyman — a respectable and lucrative profession — but John's half-hearted attitude to his studies gave him second thoughts. He decided in 1793 to train him as a miller instead, but by this time Constable had developed a keen enthusiasm for painting. He had already used his penknife to carve an outline of the mill at East Bergholt onto one of its timbers (p. 8); later, the same mill would feature on the horizon of *Golding Constable's Kitchen Garden* (p. 77) but for a year it was his place of work. Most of his admirers agreed that his time at the mill was well spent, since he always had to

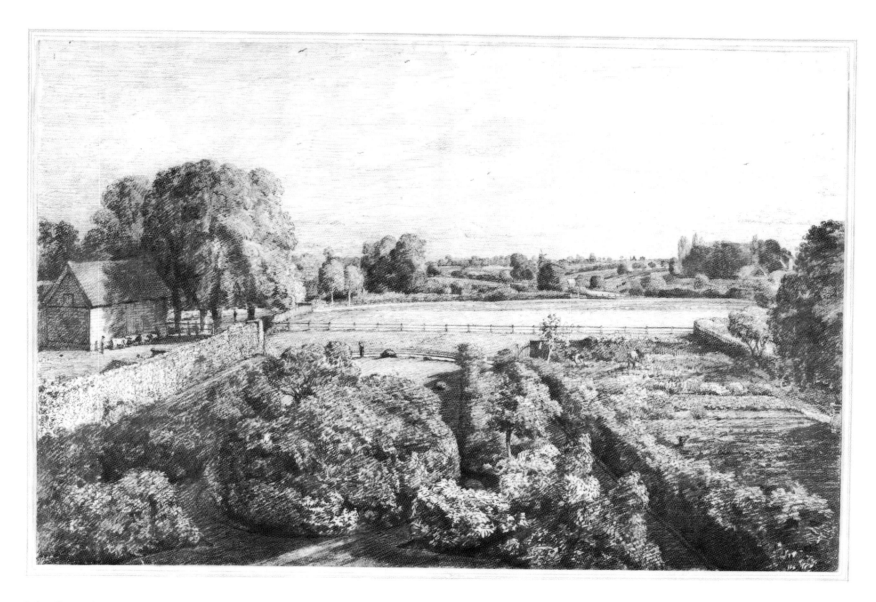

John Constable: *View at East Bergholt over the Gardens at Golding Constable's House, c.* 1814.

keep a watchful eye upon the weather, preparing him for his later campaign of cloud and sky studies (pp. 95, 97).

His closest friend at this time was John Dunthorne, the local plumber, glazier and village constable, of whom C. R. Leslie wrote, condescendingly, that he 'possessed more intelligence than is often found in the class of life to which he belonged'. Dunthorne's devotion to landscape painting matched that of Constable and he proably instilled in the younger man an early enthusiasm for outdoor study. David Lucas, Constable's engraver, described them as 'very methodical in their practice, taking their easels with them into the fields and painting one view only for a certain time each day. When the shadows from objects changed, their sketching was postponed until the same hour next day.' There is no reason to doubt Lucas's account since he presumably had it from the artist himself, although it does sound remarkably like descriptions of Constable's later *plein-air* work on the *View of Dedham* (p. 71); it may simply be that habits acquired early remained with him, but unlike Turner, Constable's youthful skills were hardly prodigious and it was not until his mid-twenties that his study before nature bore obvious fruit.

Constable and Dunthorne eventually became estranged, partly because the latter was highly unconventional (he and his wife had married through a newspaper advertisement) and a known atheist. His friendship would have been a severe embarrassment to the artist when he was courting the local rector's granddaughter. But a family connection remained: his son Johnny became Constable's studio assistant in 1824 and stayed with him for five years. Amongst his duties he was required to help produce replicas of his masters' most successful paintings, including it seems, the duplication of *The Lock* (p. 103), *Salisbury Cathedral, from the Bishop's Grounds* (p. 101) and *Harwich Light-House* (p. 91).

John Constable: *Incised Outline of a Windmill*, 1792.

FRIENDS AND MENTORS

In the late eighteenth and early nineteenth centuries, the education of an aspiring artist was provided only partly by the official teaching institutions. Constable, like many of his peers, attended the Royal Academy Schools, where he was taught to draw correctly from prints, plaster casts and the life. There were serious shortcomings to this approach. The Royal Academy, in its concern to stress the dignity of the painter's profession and lift its social status, had sought to play down the craft skills which were

once taught by the guilds. Young artists heard lectures on ancient history, literature, anatomy and the theory of painting, but were offered no systematic training in the use of oils until 1819. Constable's colleague, William Etty, sought to make up for this by paying Sir Thomas Lawrence 100 guineas to be received as a pupil for a year. Lawrence's teaching was dilatory and Etty was left to proceed by trial and error, without guidance and with largely unsatisfactory results.

Aspiring landscapists were particularly disadvantaged. The training offered at the Royal Academy was directed towards the production of history painters; there was no tuition that was relevant to landscape art as such. In this respect, the education of the German artist Caspar David Friedrich, Constable's close contemporary, offers a marked contrast: at Copenhagen, one of the most distinguished academies in northern Europe, his progress was nurtured by the leading Danish landscape painter Jens Juel. In England, it was up to the artists themselves to supplement the Royal Academy's teaching by informal means, hence the overwhelming importance of Constable's earliest friends and mentors.

In 1796 Constable was staying with his mother's relatives, the Allens, at Edmonton, where he was introduced to John Thomas Smith, teacher, artist, writer and antiquarian. 'Antiquity Smith', as he was known, enjoyed a modest fame as the biographer of the eighteenth-century sculptor Joseph Nollekens, but he was also well versed in the theory of landscape and published his own slight contribution, *Remarks upon Rural Scenery*, in 1797. Constable helped to collect subscriptions for the book, whilst Smith, together with his friend, the painter John Cranch, took charge of the young man's education. Cranch provided him with a list of the reading he considered indispensable for an artist, together with valuable study hints; Smith confirmed him in his love for

humble domestic scenery and schooled him in the excellences of Thomas Gainsborough. Smith also performed one other great service for Constable: in 1798 he finally persuaded Golding Constable to allow his son to pursue a career as a painter.

The practice of open-air painting, which developed through the work with Dunthorne, was reinforced by his meeting in 1797 with George Frost, an amateur artist much older than Constable, but with a solid local reputation. Frost loved the Suffolk landscape, but he also possessed a detailed knowledge of the work of Gainsborough. He collected his drawings, imitated his manner and researched the locations around the River Orwell where he was believed to have worked. Between them, Frost and Smith encouraged Constable's enthusiasm for Gainsborough until he became a figure of enormous importance to the young painter. He became a role model to Constable by proving it was possible for a local landscape artist to become one of the acknowledged masters of the British School of painting.

Gainsborough's early work was an object lesson in reconciling open-air study with the demands of a finished painting; he also demonstrated how an attachment to particular scenes and places, none of them distinguished in themselves, might result in paintings that were of more than parochial interest. When Constable wrote in 1799 that the region around Ipswich was 'most delightful country for a landscape painter; I fancy I see Gainsborough in every hedge and hollow tree', he may already have been drawing private comparisons with his own devotion to East Bergholt. But at this stage he was very selective where Gainsborough was concerned, and only gave his whole-hearted approval to early naturalistic scenes such as *Cornard Wood* (p. 10), a picture that was eventually purchased by his maternal uncle, David Pike Watts. Gainsborough's later works, he implied, were too

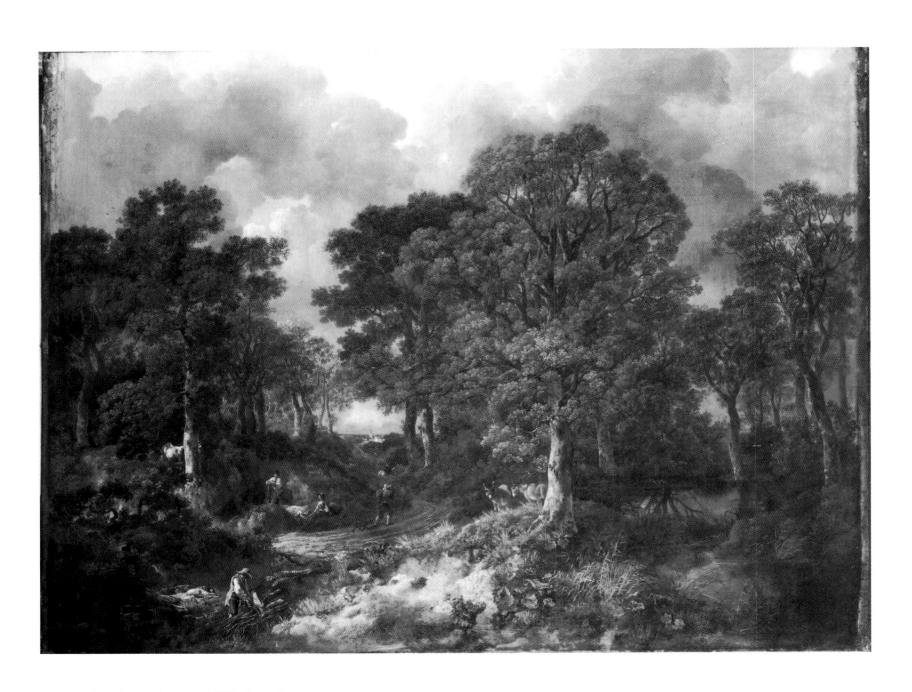

Thomas Gainsborough: *Cornard Wood*, 1748.

mannered — a judgment he was to revise at a later stage in his career when his own paintings departed from the strict canons of naturalism.

Frost, Smith and Dunthorne all played a significant part in shaping Constable's approach to his art, but the most important of his early mentors was Sir George Beaumont (p. 11), whom he met in 1795 whilst Beaumont was visiting his widowed mother, who lived in Dedham. Although he had a formidable reputation as a collector and connoisseur, Beaumont made many enemies in the Royal Academy and has often received a bad press from historians because he was an implacable opponent of Turner's art. He believed that its extravagances would lead young British painters away from nature. Turner, for his part, regarded Beaumont as a 'pretender who[se] utmost knowledge is a few practical terms . . . [and] . . . whose great pride is to point out the beauties of his own collection, expecting an humble defference to his opinions'.

To Constable, however, who had much to learn, Beaumont was generous and encouraging. He showed the connoisseur some painstaking but rather lacklustre copies he had made from engravings after the Raphael Cartoons, and Beaumont, probably with more kindness than honesty, 'expressed himself pleased' with them. In return he showed Constable the *Landscape with Hagar and the Angel* by Claude Lorraine (p. 12), a work he treasured so much that he carried it with him wherever he journeyed. Constable did not need to feign 'humble defference' to Beaumont's opinions, for the Claude may have been the first truly great painting he had seen and it left an abiding impression upon him. Its influence is easily discernible in the two versions of *Dedham Vale* which span a quarter-century of his working life (pp. 47, 117); in fact the larger painting of 1828 may have been intended as a tribute to Beaumont, who had died the previous year.

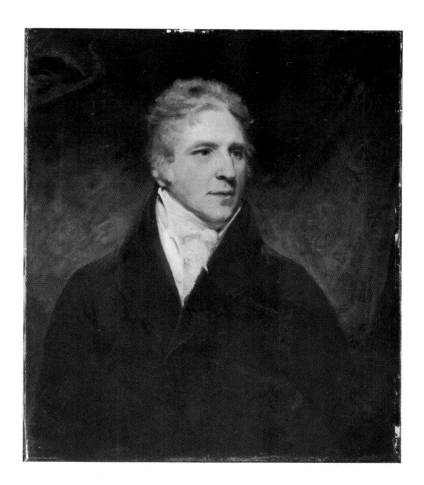

John Hoppner: *Portrait of Sir George Beaumont*, 1806.

To most writers and artists of Constable's generation, Claude represented the epitome of landscape art. Throughout the eighteenth century English collectors pounced upon his works whenever they appeared for sale, and in 1811 Turner could confidently claim that all the finest specimens were on this side of the English Channel. These included the Altieri Claudes, which Constable saw at William Beckford's London residence, and the two seaports belonging to John Julius Angerstein, which he studied and later used in the Flatford oil sketches of

Claude Lorraine: *Landscape with Hagar and the Angel, c.* 1646.

1810–11 (p. 57) and *Boatbuilding* exhibited in 1815 (p. 73). It was, however, the smaller, informal, pastoral pictures belonging to Beaumont, such as the *Hagar* or the *Landscape with a Goatherd and Goats* (p. 13) which exercised the greatest hold upon him.

Beaumont's importance extended beyond the glories of his collection, for he was also an accomplished amateur painter who exhibited his work at the Academy. As such he could offer practical advice, and Joseph Farington, a mutal friend, saw his influence quite clearly in the

Claude Lorraine: *Landscape with a Goatherd and Goats*, 1637.

younger man's work. He wrote in July 1801, that Constable's trees were 'so like Sir George Beaumont's that they might be taken for his'. Farington himself was a landscape painter and founder member of the Royal Academy, but he is now remembered mainly for his diaries — an extraordinary chronicle of the English art establishment. Few men were better equipped to record the life of the Academy, for he was an adroit politician, but one who seemed able to secure confidences from all and sundry. Above all, he was a loyal friend to Constable and helped to shape his career; he lent him pictures to copy, among them a Richard Wilson, for whom Farington had the highest regard, but more significantly, he became Constable's guide through all the complexities, protocol and politics of the Royal Academy.

THE ROYAL ACADEMY

Farington was the means through which he entered the Academy Schools. Constable called on him for the first time in February 1799 with a letter of introduction from the author Priscilla Wakefield. The many friends they had in common, such as Beaumont and Dr John Fisher, the King's chaplain (later Bishop of Salisbury), guaranteed him a warm reception. Farington told him that 'he must prepare a figure' as a demonstration of his competence, and having done so, he was admitted as a probationer to the Royal Academy Schools and properly registered in the following year. Constable's earliest experiences in London, as he confided them to Dunthorne, were rather mixed. He rejoiced in the collections of Old Master paintings to which he now had access, and even told his friend that 'I find my time will be more taken up in *seeing* than in painting.' But it was productive research and he regularly made new discoveries: 'I have

the loan of a sweet little picture by Jacob Ruysdael to copy,' he wrote. 'Since I have been in town I have seen some remarkably fine ones by him, indeed I never saw him before.' As with Claude, he still thought it worthwhile copying from Ruysdael long after his apprenticeship years (p. 15). He also managed to supplement his father's modest allowance by producing drawings that were sold by J. T. Smith at reasonable prices.

His personal and social life were less satisfactory. He was often homesick, once confessing to Dunthorne that 'This fine weather almost makes me melancholy; it recalls so forcibly every scene we have visited and drawn together.' And if the account he gave of his typical day can be relied upon, he had little in the way of recreation, and perhaps few friends of his own age. For about eighteen months Constable's closest friend in London was Ramsay Richard Reinagle, his exact contemporary, but a far more accomplished and wordly figure. They shared lodgings, jointly purchased a Ruysdael and in 1799 Reinagle stayed with Constable's family in Suffolk. Eventually the relationship soured: he found Reinagle's attitude towards art cynical and exploitative, and although Constable was prone at times to adopt a tone of lofty moral superiority, Reinagle was undoubtedly dishonest. In 1848, long after Constable's death, Reinagle created a scandal by purchasing a landscape and exhibiting it at the Royal Academy as his own work.

If he had little in common with his fellow students, some of the academicians themselves were friendly and encouraging. Besides Farington (to whom he later referred as *his master*), he received kindly advice from the President, Benjamin West. When Constable suffered an early rejection at the Academy's exhibition, West told him, 'Don't be disheartened, young man, we shall hear of you again; you must have loved nature very much before you could have painted this.' And he went on to offer a practical lesson in chiaroscuro. Constable's early work was unremarkable, but West, like Farington, must have found a spark of promise for in 1802 he persuaded Constable to refuse an offer of secure employment as a military drawing master. Unless he had real faith in the young man's potential, it would have been cruel and irresponsible advice.

The rejection of this post, so thoughtfully arranged for him by Dr Fisher, marked a watershed in Constable's early career. It forced him to commit himself: 'Had I accepted the situation offered,' he told Dunthorne, 'it would have been a death-blow to all my prospects of perfection in the art I love.' There had been occasions when Farington found him weak-willed and wanting in application, but in May 1802, he claimed to 'have thought more seriously of my profession than at any other time of my life'. He reviewed his previous work, visited Beaumont's collection to draw upon the example of the Old Masters, and returned 'with a deep conviction of the truth of Sir Joshua Reynolds' observation, that "there is no easy way of becoming a good painter"'.

The Royal Academy was thoroughly imbued with the doctrines and posthumous influence of Sir Joshua Reynolds (p. 16), its first president, and Constable was no exception. When making brief notes for his lectures in the 1830s, he wrote:

All Art in Europe
roused into life by
Sir Joshua Reynolds
in England —

Constable may be forgiven for overstating his case. Prior to the foundation of the Royal Academy, and Reynolds's presidency, England was renowned only for its lack of great painters and struggled, in the words of the Redgrave brothers 'against an old prejudice — namely, that art is

John Constable: *Winter: A Copy after Jacob van Ruysdael*, 1832.

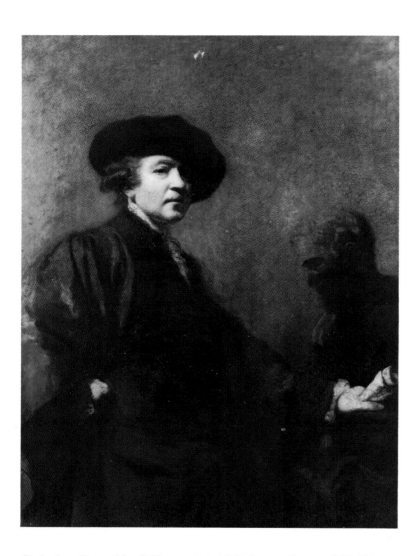

Sir Joshua Reynolds: *Self-portrait in his Robes as a Doctor of Civil Law of Oxford University*, 1773–80.

neither congenial to our soil nor to our nature, and cannot flourish among us'. Reynolds's career gave the lie to all such insinuations because he enjoyed European fame, both for his paintings and his writings. The *Discourses*, his published lectures to the students of the Royal Academy, provided (among other things) a sound and elegant resumé of European academic theory; they also raised the morale of young English painters. Constable celebrates

Reynolds's formative role in the development of a British school of painting in *The Cenotaph* (p. 137) of 1836.

The *Discourses* were on the list of recommended reading supplied by John Cranch in 1796, but he also offered some words of warning:

> be cautious it does not bias you against *Familiar* nature, life and manners, which constitute as proper and as genuine a department of imitative art as the *sublime* or the *beautiful* . . . The *Discourses* are a work of unquestionable genius, and of the highest order of literature; but they go, if I may so express it, to establish an *aristocracy in painting*: they betray, and I believe have betrayed, many students into a contempt of everything but *grandeur and Michael Angelo*: the force, and the splendid eloquence, with which the precepts are inculcated, makes us forget, that the truth of Teniers, and the wit and moral purposes of Hogarth, have been, and for ever will be, at least *as* useful, and diffuse at least as much pleasure, as the mere *sublimities* of Julio [Romano] and Raphael.

Cranch was outspoken in his criticisms of Reynolds, but he drew attention to themes within the *Discourses* that might easily have intimidated or discouraged a young landscape painter. The notion that there was a hierarchy of subject-matter (or an aristocracy, as Cranch put it) was fundamental to academic teaching until well into the nineteenth century. Historical paintings were granted a higher status than portraits, whilst portraiture in turn was considered a more dignified form than landscape. James Barry, the Royal Academy's Professor of Painting, described landscape as one of the 'baser branches of painting' because it dealt with 'inanimate matters, in which the human mind, and consequently the genius of the artists . . . [has] . . . little or nothing to employ itself upon'.

The most ambitious landscape painters of the day, such as Constable and Turner, were not content to see their chosen art treated as an inferior genre. They attempted, in different ways, to show that landscape might possess the intellectual and moral range normally attributed only to history paintings. As a painter of grand historical landscapes Turner's genius was quickly acknowledged, but in Constable's case it was a long, hard struggle, because, as C. R. Leslie pointed out, he worked within 'the humblest class of landscape', depicting what Cranch referred to as '*Familiar* nature'. There was thus an aristocracy of kinds, even within landscape itself. Pictures were judged partly by their subject-matter and partly by the degree to which they were 'improvements upon nature'. Ideal landscapes also took precedence over the faithful representation of rural scenes to which Constable was committed.

Like most academic theorists Reynolds maintained a distinction between ordinary, everyday nature and ideal or *general* nature. Dutch painters, according to him, were painters of ordinary nature, recording their landscape with a 'portrait-like' fidelity, whereas Claude had idealized nature by selecting 'various beautiful scenes and prospects' and combining them into something closer to perfection. Reynolds, predictably, counselled students to follow Claude's example rather than that of the Dutch. He even supported his argument by claiming that whereas the common masses were equipped to enjoy a Dutch painting, only a sensitive and distinguished élite had the taste and discrimination to appreciate the 'higher' beauties of a landscape by Claude.

Constable was forced to address these issues because they were at the heart of his practice as a painter of rural landscape. He responded not by repudiating Reynolds but by amending and adapting his ideas. To Constable moral integrity played a greater part than taste in the ability to judge landscape art. He implied that to appreciate any landscape, however humble, one must first learn to see nature clearly, which in turn required purity of heart. As an example of the pure in heart he pointed in 1821 to the naturalist, Gilbert White, the author of *The Natural History of Selbourne.* He wrote that:

> The mind and feeling which produced the Selbourne is such a one as I have always envied . . . It only shows what a real love for nature will do — surely the serene and blameless life of Mister White, so different from the folly and quackery of the world, must have fitted him for such a clear and intimate view of nature.

The conviction that there was a moral dimension to landscape painting remained with Constable all his life. It gave him the satisfaction of attributing his lack of recognition to the moral inadequacy of his contemporaries; it allowed him to remain loyal to both Claude and the Dutch; but above all it subverted the academic hierarchy of subject-matter.

Reynolds was not as dogmatic as a brief account of his writings might suggest. Constable may have had difficulty in accommodating some of his doctrines but he would certainly have been encouraged by the fourteenth *Discourse*, a tribute to Thomas Gainsborough. Of his colleague and rival, Reynolds said: 'If ever this nation should produce genius sufficient to acquire to us the honourable distinction of an English School, the name of Gainsborough will be transmitted to posterity . . . among the very first of that rising name.' Reynolds even went so far as to declare the superiority of Gainsborough's landscapes and portraits to the historical works of Pompeio Batoni and Anton Raphael Mengs, two of the most celebrated painters on the Continent. Whatever Reynolds

may have said elsewhere about the importance of subject-matter, Constable could not fail to have been impressed by the fact that such praise was bestowed upon a painter of the Suffolk landscape.

A NATURAL PAINTURE

For the first time in 1802 Constable had a work accepted for the Royal Academy's exhibition. On the strength of his one exhibit he was severely critical of the rest of the work on show, telling Dunthorne:

> There is little or nothing in the exhibition worth looking up to — there is room enough for a *natural painture*. The great vice of the present day is bravura, an attempt at something beyond the truth. In endeavouring to do something better than well they do what in reality is good for nothing. *Fashion* always had, & always will have its day — but *Truth* (in all things) only will last and can have just claims on posterity.

Constable's search for a *natural painture* (or painting) dominates the first half of his professional life, along with his wish to produce landscape art with a serious moral and intellectual aspect. The first requirement for a 'natural painter' was a whole-hearted commitment to nature itself, but coupled with a cautious approach to the Old Masters. He believed that to imitate art at the expense of nature was a fatal mistake for a landscape painter, hence his strong objections to the creation of a National Gallery in 1822: 'should there be a National Gallery,' he argued, 'there will be an end of the art in poor old England . . . The reason is plain; the manufac-

turers of pictures are then made the criterions of perfection, instead of nature.' He knew it was impractical and undesirable to eliminate the Old Masters from an artist's education, but insisted there was a right and a wrong spirit in which to approach them. The wrong way was to follow them uncritically; the right way was to learn from their experience of transcribing nature. Raphael and Claude, he argued, approached perfection in their art because 'they had the experience of those who went before, but did not take them at their word — that is, imitate them.'

These matters were of more than academic importance for Constable as he had to strike a balance between art and nature in his own work. In the early watercolour of *Dedham Church and Vale* of 1800 (p. 45) he had serious difficulties resolving his observations of the Suffolk landscape into a harmonious and satisfying picture. When he returned to the motif again in his small upright oil of 1802, he did so with the example of Claude in mind. The composition of his *Dedham Vale* is successful because it follows Claude's *Landscape with Hagar and the Angel* very closely, but it does so without compromising Constable's close attention to nature. With some justice he would admit to drawing upon Claude's experience but not to imitating him, since the work was painted before the motif, one of the 'laborious studies from nature' he told Dunthorne he intended to make from the scenery around East Bergholt. Here, as on many occasions, the advice of Sir Joshua Reynolds may have been important. He had condemned 'general copying' from the Old Masters as 'delusive industry', and recommended instead that young painters should set out to compete with their chosen model, attempting to produce something that would serve as a companion to it. In many respects *Dedham Vale* does provide a suitable companion to Sir George Beaumont's Claude.

The small *Dedham Vale* was intended from the outset as a study rather than a picture for exhibition, but he continued to work from nature in oils in his Academy paintings, at least until 1817. Other painters besides Constable worked outdoors in oils, for it became one of the leading principles of English naturalism in the two decades between 1800 and 1820. John Varley, who was best known as a water-colourist and teacher, took some of his pupils, including John Linnell and W. H. Hunt, out along the River Thames to sketch in oils. Peter de Wint and David Cox sketched in oils as a prelude to their finished naturalistic landscapes, whilst Turner instituted the awkward practice of sketching on a full-size canvas and occasionally working the sketch to completion in the studio.

Constable's approach to *plein-air* work was more rigorous than any of these. Like them he would sketch out of doors in oils, as he did at Flatford between 1810 and 1811, but he frequently went a stage further, attempting as far as possible to complete his pictures before nature. His convictions were shared by the Scottish miniaturist Andrew Robertson, an acquaintance of Constable who entered the Royal Academy in 1801. He wrote 'Were I to study landscape, I would finish in the field . . . It is not sketching, but finishing from nature that makes the great artist.' It was a noble ideal but in an era before the invention of tube paints, it was also a difficult and inconvenient one; oil colours prepared beforehand were stored in small sachets of leather or pig's bladder, and when required they were punctured with a pin. To sketch under these conditions was one thing, but to complete an exhibition picture with the required degree of finish and detail was an arduous undertaking. Nonetheless, finishing from nature remained an important ideal for Constable until perhaps as late as 1816, when he was worried that his marriage and honeymoon would interrupt *plein-air*

work on *Flatford Mill* (p. 83).

Open-air finishing brought other constraints, for beyond certain dimensions a canvas became simply unmanageable. *Flatford Mill*, which measures 101.7 × 127 cm., is probably the largest to include outdoor work, but by the standards of the Royal Academy's exhibition it was not a big picture. The walls of Somerset House were crammed with paintings, their frames touching one another, so that individual pictures were frequently eclipsed by their neighbours. Artists were forced to compete for attention: Turner and Sir Thomas Lawrence, for example, were accused of heightening their colours or 'painting up for the exhibition'; many painted on a scale large enough to stand any competition. Constable's subtle agricultural landscapes were generally small, and even the more ambitious ones, like *Dedham Vale: Morning* of 1811 (p. 63) were easily overlooked. He eventually realized that to secure anything other than mild praise from critics and colleagues, he would have to paint on canvasses too large for work in the fields.

To a modern eye, studio pictures like de Wint's *Cornfield* (p. 27) or Turner's *Frosty Morning* (p. 27) appear no less 'truthful' than Constable's *Boatbuilding* (p. 73) or *View of Dedham* (p. 71) which were painted largely out of doors. But a more revealing comparison would be between Constable's earlier and later work. In the 1820s he begins to depart from the strict naturalism of the previous decades; a work like *The Leaping Horse* (p. 109) of 1825 is striking more for the manner in which it is painted than for what it depicts. This is in strong contrast with the younger Constable who sought a *natural painture*, could see no 'handling' in nature and regarded a manner as a vice. The changes which came over his art in the 1820s were brought about by many things, but not least by the fact that he took to his studio.

TRAVELS AND TOURS

Constable once praised the Dutch artists of the seventeenth century for being 'stay at home' painters, and following their example, he devoted most of his energies in his earlier career to seeking 'a pure and unaffected representation' of his native scenery. But there were numerous occasions when he was drawn away from his usual subject-matter. In 1801 he visited Derbyshire to stay with a relative, Daniel Whalley. During his visit he made a sketching tour of the Peak District, taking in the most celebrated beauty spots of the area such as Matlock High Tor and Dovedale. Picturesque touring was virtually *de rigueur* for an ambitious landscape painter, and Constable was prepared at this stage to follow the convention. He may have been encouraged to tour by his 'master' Farington, for whom regular travel was a necessary part of his profession, and whom he met (apparently by coincidence) in Derbyshire.

In spite of the acknowledged beauty of the Peak District, Constable neither repeated his tour nor worked his sketches into anything more substantial. Following a pre-arranged itinerary, and depicting sites he knew had been visited by countless other artists did not really suit him, although he was persuaded to tour once more in 1806 by his uncle, David Pike Watts. Watts, who fancied himself a connoisseur, took a keen interest in his nephew's progress. At times this bordered on blatant interference, but on this occasion he was generous enough to finance a seven-week trip to the Lake District, during which Constable stayed with the Harden family of Brathay Hall, at the northern end of Lake Windermere. The Lakes had become the fashionable haunt of both poets and painters, rivalling the mountains of Scotland and North Wales in popularity. Before the war with France, English painters such as Francis Towne or John Robert Cozens were able to take advantage of Alpine scenery, but once the Continent was sealed off, the Lakes became the chief source of sublime landscape imagery.

In his biography of Constable, C. R. Leslie minimized the importance of his Lake District tour. The artist told him, late in life, that 'the solitude of mountains oppressed his spirits', and Leslie concluded that 'his mind was formed for the enjoyment of a different class of landscape.' It now seems, however, that the Lakeland tour was an important episode in his early career. Watts (who had owned property in the district) may have suggested the tour, but nothing compelled Constable to go; on the contrary, he seems to have responded to the scenery with awe and alacrity. His host, Mrs Harden, was impressed by his enthusiasm, describing him as 'the keenest at the employment I ever saw'. He sketched indefatigably, developed his watercolour technique and learned to respond to unfamiliar terrain and atmospheric conditions. His view of *Windermere* (p. 53) was painted in reasonable weather, but Constable did not allow the unpredictability of the elements to deter him; a sketch of *The Vale of Newlands* (in the Fitzwilliam Museum, Cambridge) was made during a storm and the climatic details inscribed in pencil on the back; others are spotted with rain.

If his sketches fell short of capturing the subjects he had chosen, he corrected them with written reminders in case he should ever work them up into finished pictures. At times he called upon his experience of the Old Masters to assist him, for if he could not always match the appearances of nature, he knew others who had. One of his inscriptions reads: 'Dark autumnal day at noon — Tone more blooming than this — the effect exceeding terrific and much like the beautiful Gaspar [Dughet, known as Gaspard Poussin] I saw in Margaret Street.' He is also thought to have learnt from his contemporaries, since the Lake District work occasionally seems close to

that of Thomas Girtin, who was well represented in Beaumont's collection.

Constable hoped that the time and energy he invested in Lakeland would reap a dividend at the Royal Academy. He showed Lake District scenes there in 1807 and 1808, and prepared a five-foot picture of Borrowdale which Farington thought too unfinished for the exhibition in 1809. Little is now known of these oil paintings, which represents a serious gap in our knowledge since Constable was occupied with them for nearly three years at an important stage in his development. In other respects, his spell in the Lakes was important for widening his circle of patrons (though largely for portraits) and for his meeting with William Wordsworth, another, albeit more famous, protégé of Sir George Beaumont.

The Lake District oils were not his only bid for sales and recognition in the first decade of the century. He made a surprising departure in 1806 by showing a watercolour of *The Battle of Trafalgar* (p. 51). Three years earlier he had spent nearly a month aboard the East Indiaman, *Coutts*, sailing from London to Deal and back, taking in the naval dockyards at Chatham. His activities there are described in a letter to John Dunthorne: 'I hired a boat to see the men of war, which are there in great numbers. I sketched the *Victory* in three views. She was the flower of the flock, a three decker of (some say) 112 guns. She looked very beautiful, fresh out of Dock and newly painted.' When Constable discovered he had left all his sketches on the *Coutts* he 'was ready to faint', but they were returned to him and he made opportunistic use of them after the Battle of Trafalgar. His depiction was highly competent, drawing on a distinguished tradition of English sea battle pictures which included the work of the van de Veldes, Samuel Scott, and more recently, Philip de Loutherbourg. But he had no lasting enthusiasm for the genre and years later dismissed a competition for a

painting to commemorate Nelson's victory as irrelevant to his interests.

PORTRAITS AND RELIGIOUS SUBJECTS

Whilst he was struggling to succeed as a landscape painter throughout the first decade of the century, his meagre income was derived largely from portaiture. Constable's parents were keen for their son to develop a portrait practice since it was known to be more lucrative than landscape, and the most successful portraitists like Reynolds or Lawrence enjoyed both wealth and status. Constable's employment, however, was lowly. In 1804 Farington wrote that he was 'much employed painting portraits large as the life for which He has *with a hand* 3 guineas — without 2 guineas — This low price affords the farmers & c to indulge their wishes and to have their Children and relatives painted.' Later his patrons were drawn from higher up the social scale. In 1807 he was introduced to the Earl of Dysart and his sister-in-law, who employed him largely to make copies of family portraits by Reynolds and Hoppner. It was hack work, but, as C. R. Leslie remarked, Constable may not have found it altogether uncongenial since Reynolds could always offer him a lesson in colour and chiaroscuro.

By the standards of the day his prices were embarrassingly low but they helped to supplement his allowance for about fifteen years. They rose gradually over the following decade but did not remotely match those of his colleagues who specialized in portraiture. The works he produced on commission, like the group portrait of the Bridges family of 1804 (now in the Tate Gallery), are often highly competent, but portraiture was a competitive

business. Constable, who regarded it as an unfortunate necessity, did not exhibit his efforts in an attempt to make a general reputation for himself. A rare exception was the portrait of the *Rev. John Fisher* (p. 22), which was shown in 1817, but Fisher was not merely a patron, he was a devoted friend and his portrait was valued accordingly.

On rare occasions Constable entered the field of religious painting and produced altarpieces for Suffolk and Essex churches. The first, *Christ Blessing the Children*, (p. 23) was begun in 1805 for St Michael's Church, Brantham. It was more dignified employment than painting local farmers and their families, but it cost him considerable effort, and as his uncle pointed out, the results were not altogether satisfactory. A devotional scene with life-size figures was beyond his experience, and he responded by adapting the style of Benjamin West with details from the Raphael Cartoons. Constable was probably aware of its inadequacies since he continued working on it for two years, but it still appears sentimental and badly managed. His remaining altarpieces, *Christ Blessing the Sacraments* (c. 1809, Nayland Church, Suffolk) and the *Risen Christ* (1822, Manningtree Church, Essex) are slightly more successful, but leave no doubt that biblical subjects were not Constable's forte.

If his altarpieces were failures, it was not from lack of religious conviction. He was a devout Anglican, but one who believed that religious sentiments could find expression through landscape just as surely as through conventional biblical pictures. Describing a scene by Nicholas Poussin, he wrote, 'it is the most affecting picture I almost ever stood before. It cannot surely be saying too much when I assert that his landscape is full of religious and moral feeling, and shows how much of his own nature God has planted in the mind of man.' There were other painters, like Samuel Palmer and Caspar David Friedrich, who displayed a religious attitude to

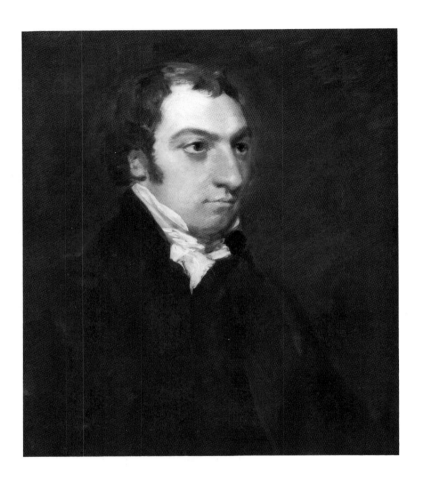

John Constable: *Portrait of the Rev. John Fisher*, 1817.

landscape, but their works are more overtly symbolic. In Constable's work overt or sustained symbolism of this type is much rarer, particularly in his early productions. It is found in his small painting of *'A church porch'* (p. 55), which is a meditation on mortality and salvation, but the religious feelings and experiences he received from nature were often of a more general kind and thus difficult to express in pictorial terms. To Constable, spring in East Bergholt, for example, evoked the Christian doctrine of the Resurrection; paraphrasing Wordsworth, he wrote:

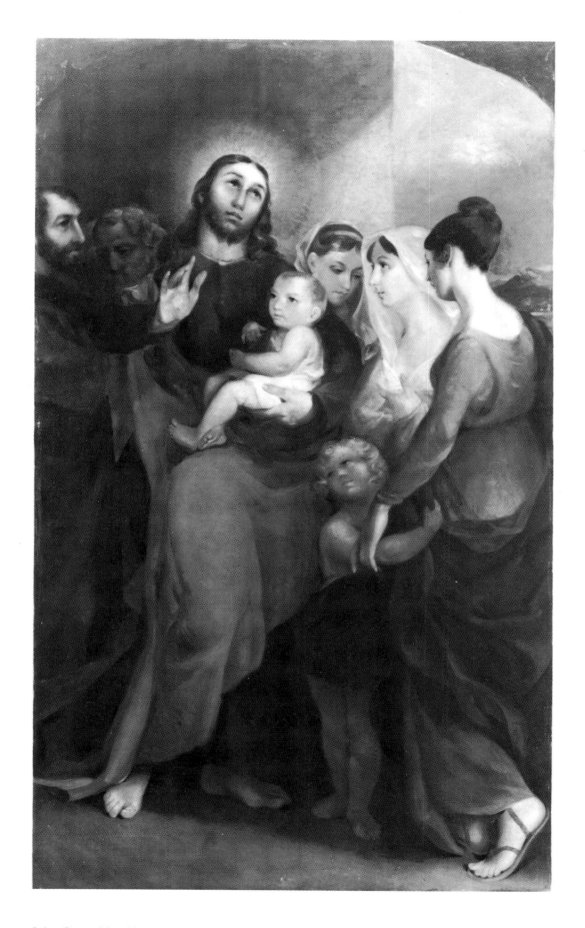

John Constable: *Christ Blessing the Children, c.* 1805.

'Everything seems full of blossom of some kind and at every step I take, and on whatever object I turn my eyes, that sublime expression of the Scriptures "I am the resurrection and the life" seems as if uttered near me.' But visitors to the Royal Academy rarely looked for such sentiments in Constable's agricultural landscapes.

THE AGRICULTURAL LANDSCAPE

By 1808 Constable was still unable to earn a living from his art but he was well known at the Royal Academy. Apart from the older Academicians, he had met and become friendly with the young Scottish genre painter, David Wilkie. Wilkie's career and prospects, however, could not have been more different. His talents were recognized almost immediately, and after showing his *Village Politicians* at the Academy in 1806 he was fêted as the most promising young artist of the day, temporarily eclipsing even Turner. In comparison, Constable must often have felt that he was, in his father's words, 'pursuing a shadow'. His friend Thomas Stothard had advised him in 1807 to seek election as an associate of the Royal Academy, but Farington, wisely, counselled against it, fully aware that he had produced nothing substantial enough to warrant his election.

This situation, which had been thoroughly discouraging, became critical after 1809. In the summer of that year he returned to East Bergholt and fell in love with Maria Bicknell (p. 25), whose father was solicitor to the Admiralty, and whose grandfather was the Revd Dr Rhudde, Rector of East Bergholt and Brantham. Maria Bicknell had been brought up to expect a high standard of living and a certain social status. She thought it unlikely that they would manage on less than £400 a year, a sum that would represent great wealth to most, and was

certainly beyond anything Constable could hope to secure. It is not surprising therefore that the Bicknell family were unhappy at having an unsuccessful painter as her suitor or that they opposed the marriage for eight years.

The strongest opposition, particularly after 1811, came from Dr Rhudde, who threatened to exclude Maria from her inheritance if the marriage went ahead against his wishes. Rhudde was once well disposed towards Constable — the altarpiece of *Christ Blessing the Children* had been for one of his churches — but when his granddaughter wished to marry beneath her he became implacably hostile. On his mother's advice Constable tried to curry favour with the rector by giving him a watercolour of *East Bergholt Church* in 1811 (p. 59), but Rhudde was unprepared to allow a debt of gratitude, however slight, to exist between them and he paid for the picture instead. The attitude of Maria's parents varied: at times they were allowed to meet, at others Constable was an unwelcome visitor at their London house. The situation played upon his nerves and often depressed his spirits.

His confidant throughout much of the turbulent courtship was John Fisher, the nephew of the Bishop of Salisbury. They met in 1811 when Constable was staying at Salisbury to paint the Bishop's portrait and their friendship continued until Fisher's death in 1832. He replaced Dunthorne as Constable's principal correspondent, offering genuine enthusiasm and support in his letters. When his financial position allowed he even purchased important examples of his friend's work, such as *The White Horse* (p. 85). They had similar backgrounds, shared the same religious beliefs (both were High Church) and were alike in their political conservatism, but above all they were temperamentally compatible. Fisher, who had a secure career in the Church, was stable and phlegmatic; Constable was anxious and prone to self-doubt. Fisher was therefore well equipped to steer

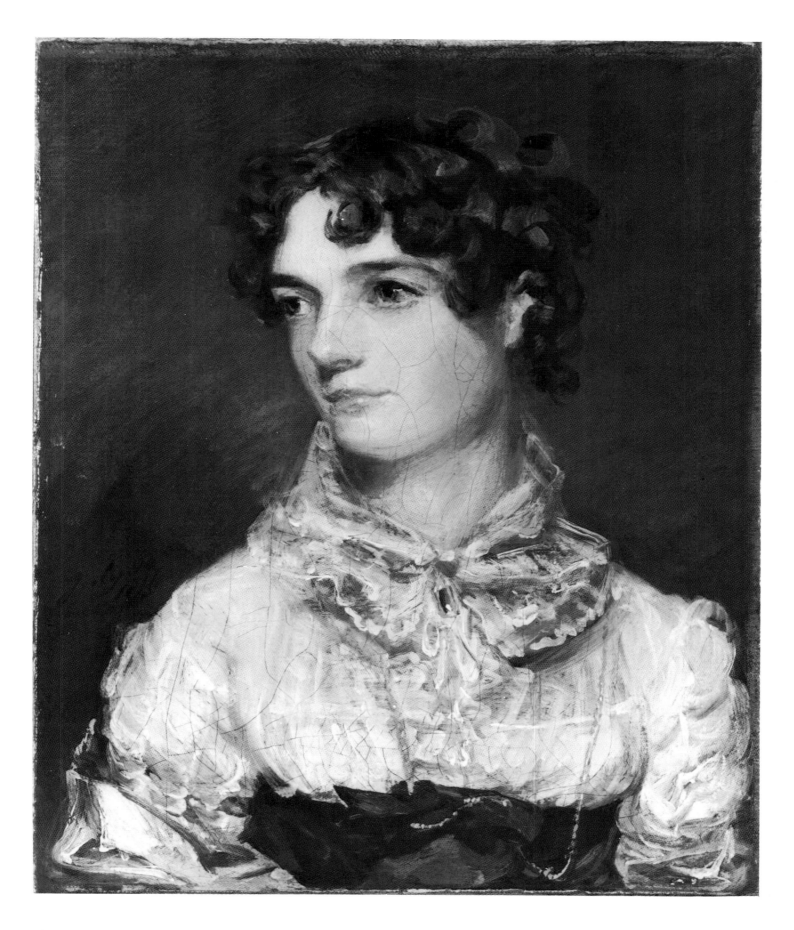

John Constable: *Portrait of Maria Bicknell, Mrs John Constable*, 1816.

his friend through his periodic crises of confidence, both personal and professional.

They both knew that if Constable wished to marry Maria Bicknell, he would first have to achieve professional success and financial independence. To that end he began to concentrate with renewed ambition upon the canal and agricultural scenes that he later described as 'my own places'. One of the first manifestations of this was the large *Dedham Vale: Morning* (p. 63), shown at the Academy in 1811. Michael Rosenthal has even suggested that the stone inscribed with the words 'Dedham Vale' was a visual pun, signifying that the picture was a 'milestone' in his art. If so, his audience certainly did not recognize it as such and it remained unsold, which augured badly for Constable's ambitions. In fact, Constable was not alone in this plight; Turner found it difficult to sell his oil paintings of agricultural subjects. He rarely attempted to send realistic pictures of rural labour like *Ploughing up Turnips near Slough* (Clore Gallery for the Turner Bequest) to the Royal Academy; they were shown in the more favourable conditions of Turner's own gallery, but they still remained on his hands. Even his *Frosty Morning* (p. 27), which was shown at the Academy and very favourably received, did not find a purchaser. It appears therefore that agrarian landscapes were more popular with artists then with the general run of their patrons. De Wint went on to produce two versions of *A Cornfield* (p. 27) even though there appeared to be a very limited market for them.

Artists were drawn to farming subjects in the early nineteenth century, not least for patriotic reasons. Since the 'agricultural revolution' it had developed as a recognizable sub-genre of landscape, and one particularly associated with the English School of painting. English artists had debated the question of their national identity for decades, but the debates were sharpened by the continuing war with France, and their subject-matter was one way for painters to distinguish themselves from their French counterparts. Furthermore, just as caricaturists like Gillray would contrast the English and French diets (roast beef and frogs, respectively) as manifestations of national character, English landscape and agriculture could easily be seen as typifying the threatened virtues of English society. They assumed a similar role in British cinema during the Second World War, in films like Powell and Pressburger's *A Canterbury Tale*.

Most significantly of all, agriculture was a matter of national importance. The Napoleonic blockade reduced imports and forced Britain to become self-sufficient, producing enough to feed its large army. To that end even marginal land was given over to cultivation. In this context, well-tended farmland and hard work such as that represented in Constable's *Ploughing Scene in Suffolk* (p. 69), or the *Cornfield* depicted by de Wint (p. 27) had patriotic connotations. Turner, for whom the war loomed large, and who wrote lines of verse about the blockade, certainly conceived his agricultural subjects in these terms. For Constable, whose family were directly involved as millers and corn merchants, these things would have had a greater personal significance, particularly since the war had driven up the price of corn and enhanced their prosperity.

The farming scenes Constable painted between 1810 and 1820 are largely characterized by efficient methods and well-disciplined labour. Whilst he often worked on his paintings in oils before the motif, he also developed the habit of making small pencil sketches, sometimes of the landscape, but often of labourers at work. In so doing he was acting on advice given to him over fifteen years earlier by his friend J. T. Smith. 'Do not', said Smith, 'set about inventing figures for a landscape taken from nature; for you cannot remain an hour in any spot, however

J. M. W. Turner: *Frosty Morning*, 1813.

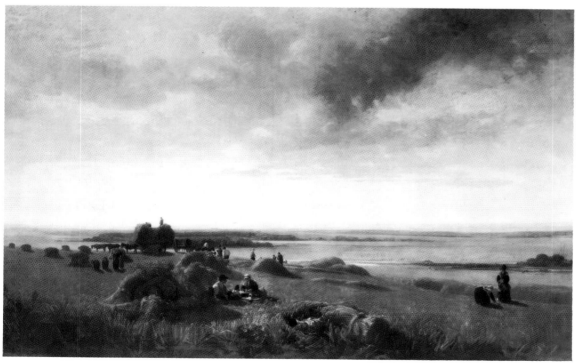

Peter de Wint: *A Cornfield*, c. 1815.

solitary, without the appearance of some living thing that will in all probability accord better with the scene and time of day than will any invention of your own.' Constable's sketches and figure studies served him as a repertoire of subjects and details and two examples from a small sketchbook used in 1813 (p. 28) were employed in the composition of his *Ploughing Scene.*

Most critics and visitors to the Royal Academy would not have appreciated the authentic details within this picture, but the knowledgeable reviewer of the *East Anglian* magazine was an exception. He treated Constable's team of only two horses as an object lesson in efficient ploughing, which, he wrote 'may be serviceable to the interests of agriculture'. Constable's agricultural scenes had a particular appeal to those with farming interests or experience, but unfortunately they were not always in a position to buy his pictures. Sam Strowger, the head porter of the Royal Academy, was a Suffolk man

John Constable: Page from a sketchbook used in 1813.

John Constable: Page from a sketchbook used in 1813.

who had worked on a farm. He demonstrated the accuracy of the reapers in one of Constable's pictures (probably the lost *Wheatfield* of 1816) to the committee arranging the exhibition, but in spite of his efforts it was not well liked. He consoled Constable by saying 'Our gentlemen are all great artists, sir, but they none of them know anything about the *lord*.' In Suffolk, the leading man in the line of reapers was known as the 'lord'.

The *Ploughing Scene* was an important painting for Constable. It found a purchaser in John Allnutt, a wine merchant from Clapham who had a model farm. Constable was always grateful to Allnutt for the lift in morale the sale had given him. It was also the first painting which he exhibited alongside a poetic text. The entry in the Academy catalogue included two lines from *The Farmer's Boy* by the 'peasant poet' Robert Bloomfield:

But unassisted through each toilsome day,
With smiling brow the Plowman cleaves his way

The phrase 'smiling brow' has often been misunderstood, for it is a sign not of pleasure but of effort and concentration. This may seem appropriate, since a ploughman could walk up to sixteen miles behind the plough in the course of a day's work, but the picture was not intended as an expression of sympathy for his lot. Constable was a strong believer in the importance of hard work on the part of the labouring classes, and his toiling ploughman is a personification of industry.

In the poets Constable admired, like Bloomfield and James Thomson, efficient husbandry is indicative of a well-ordered society. They are part of a *georgic* tradition in English poetry which celebrates the virtues and benefits of work, whilst also describing in detail the processes and operations of agriculture. Because of the parellels between their verse and Constable's pictures, his view of rural labour is often similarly described as *georgic*. The description applies not only to the *Ploughing Scene*, but also to the figures digging out a dung heap in the *View of Dedham* (p. 71) which he showed at the Academy in 1815, as well as to its companion, *Boatbuilding* (p. 73). As Michael Rosenthal has shown, the figures at work in the dry dock are each engaged upon a separate activity, but together they demonstrate the stages in the construction

of a barge as clearly as Bloomfield described the ploughman's task. Even his view of *Wivenhoe Park* of 1816 (p. 79), which is ostensibly a country house portrait, emphasizes the economy of the estate more than the house itself, although it does so to the credit of the owner, General Francis Slater-Rebow.

Most of these agricultural landscapes were intended for the Royal Academy but two of the finest, the views over his father's flower and kitchen gardens (pp. 75, 77), were not publicly shown. They were based upon a highly finished drawing (p. 7) which may itself have been exhibited, but his decision not to show the oils is a puzzling one. In both paintings the georgic imagery is dovetailed with memories of his childhood, but by the time the exhibition opened in 1816 those happy associations were overshadowed by the death of his mother and by the awareness that his father was terminally ill.

CHANGING CIRCUMSTANCES

Constable's mother was taken ill during a cold spell in March 1815 and died at the end of the month. His father had been in ill health for some time but his condition worsened and in December he collapsed. At first it appeared that his death was imminent but he rallied and lived on until May, when he died peacefully in his chair. Constable felt the deaths of his parents deeply, but they allowed him the financial independence he had been seeking. His father's estate was divided equally between his children, whilst Constable's brother, Abram, was to continue running the family business. Constable would receive £200 a year as his share of the profits, together with his allowance, a further £100 a year. With a guaranteed income on that level he could finally contem-

plate marriage to Maria, although his new prosperity did not free him from the need to sell his work: there was a shortfall of at least £100 to make up every year, before he and Maria could live in the manner her family expected. If anything, as their family increased, he was under greater obligation than ever to make a name and fortune for himself, in order to provide for his children's future.

Although Charles Bicknell, Maria's father, no longer actively opposed their marriage, relations with Dr Rhudde deteriorated alarmingly and the couple finally realized that there was no point in waiting for his consent. After finally agreeing that they would marry whatever the consequences, Constable committed an enormous and selfish *faux pas* by telling Maria he was concerned that their wedding would take him away from East Bergholt at a critical stage during his work on *Flatford Mill* (p. 83). They were, however, finally married by John Fisher at St Martin-in-the-Fields on 2 October 1816. Maria's family did not attend the service.

John Fisher, who had also married earlier in the year, invited them to spend their honeymoon with him and his wife Mary at Osmington in Dorset, where Fisher enjoyed one of his plural livings. Constable continued to work throughout their stay, carrying a sketchbook on the visits they made to Weymouth and Portland. Fisher also provided him with freshly ground paints, as he had promised, and these Constable used to continue his practice of *plein air* work, resting the lid of his paint box on his knees as an impromptu easel. A number of impressive coastal scenes were produced in this way, including that of *Weymouth Bay* (p. 81). Like his other marine paintings *Harwich Light-House* (p. 91) and *Yarmouth Jetty*, he made multiple versions of some of his Osmington and Weymouth scenes, continuing to rework the material as late as 1824.

On their return Constable and his wife settled permanently in London, eventually renting a house in Keppel Street near the British Museum. The great Constable scholar R. B. Beckett described his marriage as having 'closed . . . the first volume of his life; for although he returned to East Bergholt often enough thereafter, he came henceforward rather as a visitor than as one to whom the house where he was born still counted as home'. Constable took his last long holiday in East Bergholt in 1817; after the responsibilities that came with the birth of his first son, John Charles, in December that year, prolonged absences from London were no longer so feasible. *Flatford Mill* was therefore perhaps the last major Suffolk picture to have been worked before nature.

Events in Suffolk itself may also have begun to affect his attitudes to his native landscape. The boom conditions farmers had experienced during the war, which brought high prices and full rural employment, were reversed after Napoleon's final defeat. Abram Constable, as manager of the family business, was seriously affected by the agricultural depression. As late as 1819 he wrote to his brother, saying 'I don't know how your profession goes on, but mine is nothing to boast of.' The most serious impact, however, was upon the rural labourers. Their wages had increased by about 75 per cent during the war, but the price of bread had doubled and the post-war unemployment, when it came, caused tremendous hardship. Constable had some sympathy with the plight of the rural poor; the poetry accompanying his lost painting of *A Harvest Field: Reapers, Gleaners* in 1817 praised the charity which allowed the poor to follow the reapers, collecting whatever they left in the fields. But the scale of the distress in 1816 was beyond the scope of such occasional generosity and it led to rioting, machine-breaking and incidents of arson. With no rural police force to control or prevent them these serious episodes were repeated in 1822 and his brother Abram reported that there was 'never a night without seeing fires near or

at a distance'. Constable's previous agricultural landscapes implied that prosperity and plenty were guaranteed by a cooperative, fully employed work force but by 1817 that was demonstrably not the case.

After 1816, Constable, like other painters, turned away from realistic agrarian landscapes such as the *Ploughing Scene*, which had previously assumed such prominence in his output. No single explanation can be offered for his change of direction. His marriage played an important part by removing him from East Bergholt; the depression and riots may possibly have alienated him and undermined his georgic ideals of farm labour; he may also have realized, as Christiana Payne has suggested, that most exhibition-goers, and some of his colleagues, regarded the subject-matter as commonplace and thus unlikely to gain him the recognition he needed.

THE RIVER STOUR PAINTINGS

It was once remarked that if Constable had died when he was 40 years old, he would now be a comparatively minor figure within European painting. His fame, during and after his lifetime, was based in no small degree upon the series of six-foot paintings of scenes on the River Stour, shown between 1819 and 1825. These pictures represented a shift in emphasis in his work, inaugurated by *Flatford Mill* which he completed and exhibited in 1817. That was not a six-foot canvas but it was larger than much of his previous work, and distinctive enough for Farington to urge him to complete it for the exhibition, where it was widely noticed. Rumours eventually began to circulate about Constable's possible election to the Royal Academy and although the painting did not sell, he realized that another canal subject, on an even more ambitious scale,

might consolidate his reputation.

The *White Horse* (p. 85), the first to be painted on a six-foot canvas, was completed and exhibited in 1819, after a great deal of preparatory work. It was not unusual to see six-foot landscapes at the Royal Academy, but they were generally of historical or 'elevated' subjects, and not the 'humbler' class of landscape to which the *White Horse* would typically be consigned. It therefore attracted more notice than any of his previous paintings, even though it had been poorly hung. There were some qualms about his handling, which had changed since he began to work extensively in the studio, but most of the comment was highly favourable.

Robert Hunt, writing in the *Examiner*, thought Constable's ambitious landscape was one of the few that would bear comparison with the work of Turner. Constable had encouraged such comparisons for many years. Fisher had written that the only painting in the exhibition of 1813 that he preferred to Constable's *Landscape: Boys Fishing* (p. 65), was Turner's *Frosty Morning*. As far as we know Constable took no offence at being placed second only to Turner's magnificent piece of naturalism, but the following year he declared that he would rather have been the author of his *Ploughing Scene in Suffolk* than of Turner's *Dido and Aeneas* which were shown at the same exhibition. The *Dido and Aeneas* was a splendid historical landscape, but Constable (and some of the reviewers) thought it departed too far from nature.

By 1819 domestic naturalism played a less important role in Turner's exhibited work and it was no longer possible to compare the artists in the same terms. Robert Hunt's review recognizes this and identifies them as representatives of different tendencies in English landscape painting. Hunt wrote that Constable 'does not give a sentiment, a soul to the exterior of Nature as Mr Turner does; he does not at all exalt the spectator's mind, which

Mr Turner eminently does, but he gives her outward look, her complexion and physical countenance. He has none of the poetry of Nature like Mr Turner, but he has more of her portraiture.' Constable may have been flattered to be described as the finest of English naturalistic landscape painters, but he would also have quarrelled with Hunt's assumption that it was the artist's business to 'give . . . a soul to the exterior of Nature'. In his view an unembellished landscape could possess both 'soul' and 'sentiment'. Hunt, however, was a highly intelligent and well-informed spectator and if he was unable to discern these qualities in Constable's landscape, neither would the public.

With these reservations aside, *The White Horse* compelled the Academy to take Constable's pretensions seriously and he was finally elected an Associate on 1 November 1819, defeating the man who was to become his biographer, C. R. Leslie, by eight votes to five. This recognition was long overdue, but it represented a vindication of all his efforts and greatly enhanced his status. Good fortune followed him throughout 1819; he received £4,000 from his father's estate and a similar amount was bequeathed to his wife by their former adversary, Dr Rhudde. In the short term they were financially secure, although within three years Constable was short of money once again and forced to borrow from Fisher.

Their new prosperity allowed them to rent Albion Cottage in Hampstead and thus to spend part of the summer living outside London, whilst still retaining a house and studio in the city. The heathland scenery was in marked contrast to that of his Suffolk pictures, but Constable explored its topography continually in the ensuing years. The earliest known Hampstead painting is the small oil of *Branch Hill Pond* (p. 87) which was part of his initial exploratory work; some of the subsequent pictures, such as the Fitzwilliam Museum's *Hampstead Heath* (p. 89) exploit the high vantage point to give a panorama of the surrounding lands and villages. In 1821, when he was confident enough, he began to show Hampstead scenes at the Royal Academy, where they kept company with his large-scale River Stour subjects.

He repeated the success of *The White Horse* with *Stratford Mill*, which was shown at the Academy in 1820. Apart from the barge moored on the far bank of the river there is little in Constable's picture to suggest that the mill at Stratford St Mary was a busy location involved in the manufacture of paper. Instead of depicting the working life of the Stour, he sought to guarantee public approval by introducing the young fishermen as a pleasing anecdote. His ploy worked, since they attracted attention and comment from Beaumont and others, and earned it the nickname *The Young Waltonians*. But it would be a mistake to regard the painting as simply a failure of nerve. The superficial charm of the young anglers was intended to balance a serious concern with the natural history of the riverbank, where the prevailing winds had misshapen some of the trees and the water had killed another. He expected this evidence of natural processes at work to engage the mind and intelligence of the spectator, just as Robert Hunt believed a landscape by Turner would. Constable had agreed with the ageing portrait painter James Northcote that 'it should be the aim of the artist to bring something to light out of nature for the first time. Something like that for which in mechanics a patent would be granted.' In *Stratford Mill* he attempts to do so.

After the 1820 exhibition Constable's name was firmly associated with river and canal scenes. He considered breaking the pattern by completing a picture of *The Opening of Waterloo Bridge* (p. 131) for the following year, but Farington, with his usual wisdom, told him to capitalize on his fame by sending 'a subject more corresponding with his successful picture exhibited last May

[i.e. *Stratford Mill*]'. Constable took his advice and began work upon the *Hay-Wain* (p. 93). This, the most popular of Constable's paintings today, was a variation upon the *Mill Stream* (p. 67) which he had painted in about 1814. Both pictures are of Flatford, where Constable's family moved after the sale of their parental home. In the *Hay-Wain* he adapts his vantage point in order to include not only Willy Lott's cottage (p. 33) and the stream which fed the family mill, but also the view across the Stour into the fields beyond. Here Constable reintroduces the kind of agricultural details found in pictures like the *View of Dedham* or those of his father's gardens, but because they are placed in the background they are legible without compromising the picture's wider appeal. A team of mowers is seen at work in the far distance, and behind them hay is loaded onto a wagon; when that is fully laden the empty cart fording the stream will presumably take its place.

Because he had begun the picture late in his working year, he was hard pushed to complete it in time for the exhibition of 1821. His work on the six-foot paintings had led him to prepare full-size sketches in order to try out his ideas and material on the appropriate scale. It is a sign either of his confidence or of the pressure of an impending deadline, that the sketch for the *Hay-Wain*, though more vigorous in its handling, is very similar to the final painting. When the exhibition opened there were some quibbles about its lack of finish and Constable seems to have been a little disappointed by the mixed reception it received when compared with the great success of its predecessors. Contrary to his expectations it also failed to find a purchaser. He could not have imagined that it would subsequently receive great acclaim from contemporary French artists and critics.

In 1821 he began work on another six-foot painting entitled *A View on the Stour near Dedham* (Henry E.

Willy Lott's cottage, Flatford.

Huntington Library and Art Gallery, San Marino), whilst simultaneously making a series of oil studies of the clouds and sky (pp. 95, 97). He worked from locations on Hampstead Heath, sketching at different times of day and with varying weather conditions, often writing these details on the back. Constable had a long-standing interest in the weather and the skies, but a letter written in October 1821 to Fisher announced that he had made up his mind 'to conquer all difficulties and that most arduous one among the rest'. The sky, he went on to say, was not only the most difficult part of a landscape

painting, it was also the most important, since it provided 'the *"key note"*, the *standard of "scale"*, and the chief *"Organ of Sentiment"* . . . [it is] . . . the *"source of light"* in nature — and governs every thing.' In other words the sky determined not only the colour and chiaroscuro within a landscape, but also its expressive potential. It was the main means by which he would convey a mood, feelings or state of mind.

This belief led him into difficulties in 1823, whilst painting a view of Salisbury Cathedral for Fisher's uncle, the Bishop. He objected to the dark cloud Constable introduced into the picture, but rather than paint it out the artist presented him with a replica in which the sky was unblemished. *Salisbury Cathedral, from the Bishop's Grounds* (p. 101) was sent to the Academy in 1823, but only because it had prevented him from completing the Stour scene he had been working on, which is now known as *The Lock* (p. 103). Its completion was deferred throughout 1823 as Constable took on small commissions to bolster his finances, then made an extended visit to Coleorton Hall, the Leicestershire country house of Sir George Beaumont. There he renewed his acquaintance with Beaumont's formidable collection, particularly the Claudes, and made a conscientious copy of the *Landscape with Goatherd and Goats* (p. 99). He wrote that it 'diffuses a life and breezy freshness into the recesses of the trees, which make it enchanting' and that it represented 'almost all that I wish to do in landscape'.

In January 1824, the same month in which he resumed work upon *The Lock*, Constable was visited by a Parisian dealer called John Arrowsmith who wanted to show his work in France. In the 1820s the antipathy expressed towards each other's art during the war by French and English painters, was replaced by a period of great anglophilia. The painter Théodore Géricault and the writer and traveller Charles Nodier were both struck by the *Hay-Wain* when they saw it at the Academy in 1821. Nodier thought it was the finest picture in the exhibition, worthy to stand alongside the greatest of the Old Masters. Arrowsmith saw it when it was exhibited for a second time at the British Institution and eventually persuaded Constable to sell it, together with *A View on the Stour* and a version of *Yarmouth Jetty*. He duly showed them at the Paris Salon in 1824, where they were greeted with a loud chorus of praise from the likes of Stendhal (who doubted whether French Art had anything that would compare with them), Adolphe Thiers and Delacroix.

Delacroix's reaction was important because he was an influential figure within French romantic painting. After his visit to the Salon he wrote that 'This man Constable has done me a power of good,' and even felt compelled to retouch sections of *The Massacres at Chios* (The Louvre) upon which he was working. He was still intrigued enough to visit Constable's London studio the following year, where they discussed certain aspects of the colouring in his landscapes. In the longer term, Delacroix may have passed his enthusiasm on to Théodore Rousseau, one of the landscape painters who worked at Barbizon in the Forest of Fontainebleau. The 'Barbizon School' also included two other known admirers of Constable, Paul Huet and Constant Troyon, and it is by no accident that East Bergholt and Barbizon are now twin towns.

Constable was proud of the celebrity he enjoyed in France, and of the Gold Medal he was awarded by King Charles X. Many of his pictures remained there and continued to exert an influence, but his French reputation must be seen in context. In the mid 1820s English art was at the centre of a propaganda battle between conflicting styles. The younger painters such as Géricault and Delacroix, whom we now describe as 'romantic', admired the English bravura qualities of handling, colour and effect; but to those who upheld the neoclassical tradition

of Jacques Louis David, English painting was a dangerous model to take. David's pupil and biographer, Etienne Delécluze, was one of Constable's harshest critics in 1824, who condemned the 'affected negligence' of his pictures for being as pedantic in its way as a laboured and careful manner of painting. Constable's paintings were the focus for a vigorous ideological debate.

To his warm reception in Paris (notwithstanding the likes of Delécluze) was added a notable success at home. *The Lock* was shown to great critical acclaim and sold for 150 guineas to James Morrison, a successful draper, on the first day of the exhibition. Constable had been very nervous about the picture when he sent it to the Academy 'with all its deficiencies in hand', perhaps understandably so since it was a notable departure from his earlier canal scenes and heralded an important change in his work. He described it as 'an admirable instance of the picturesque', a category of landscape he had explored decades earlier under the influence of J. T. Smith, but one that was at odds with his later commitment to a naturalistic depiction of agricultural scenes.

The theorist Uvedale Price (whom Constable is known to have read) argued that picturesque effects were those of unevenness, intricacy and 'the two opposite qualities of roughness and of sudden variation, joined to those of irregularity'. Many of those qualities are present in Constable's picture, where they are rendered with an appropriately irregular and unevenly textured paint surface. But a return to the picturesque meant a shift in his priorities, since its qualities are more often associated with disrepair than with the well-disciplined, efficient farming of the earlier agricultural subjects. Signs of neglect abound in the *Cornfield* of 1826 (p. 113), from the dead tree and broken gate to a rutted and unverged path of the kind Price described as singularly picturesque.

The handling of the *Cornfield* is quite restrained, but for the most part Constable's brushwork is deliberately more emphatic in the major pictures exhibited after 1824. In 1821 the *Hay-Wain* had been sent to the Academy in haste and lacking 'finish'; when it was shown in Paris three years later, Constable treated those same qualities as positive virtues. He was delighted when the Director of the Louvre had it re-hung to allow closer inspection, for 'they then acknowledged the richness of the texture & the attention to the surface of objects'. Of all the canal scenes it is *The Leaping Horse* (p. 109), the last in the series, that pays the greatest attention to surface and texture. In a letter to Fisher, he emphasizes its picturesque details such as 'old timber-props, waterplants, willow stumps, sedges, old nets, &c &c,' but places far less stress upon topographical accuracy by manipulating the details in the painting, shifting the willow stump and introducing Dedham church at a point where it would not actually be visible. His primary concern, he explained to Fisher, was in finding a way of conveying the sensations one might experience in the landscape, rather than solely presenting visual 'facts'. When he described it as 'lively — & soothing — calm and exhilarating, fresh — & blowing,' it was in the same terms he had used to praise Claude's *Landscape with Goatherd and Goats*, which he said contained 'almost all that I wish to do in landscape'. Constable was beset by doubts and uncertainties throughout his work on the *Leaping Horse*; it did not sell, but he would have had the satisfaction of seeing it well received at a time when he was seeking to become a full member of the Royal Academy.

THE LATER CAREER

In 1824, Constable's pleasure at his international fame was blighted by his wife's increasing ill health. Maria's

sister and brother had both succumbed to tuberculosis and she began to display the same symptoms. Her doctor recommended a period of convalescence by the sea and so the family was moved to a house in the fashionable resort of Brighton, where Constable joined them whenever he could. On his visits he drew and sketched in oils, producing small but brilliant studies such as *Brighton Beach with Colliers* (p. 105). But on the whole he disliked the town. 'Brighton', he wrote, 'is the receptacle of the fashion and offscouring of London. The magnificence of the sea, and its . . . everlasting voice, is drowned by the din & lost in the tumult of stage coaches — gigs — "flies" &c. — and the beach is only Piccadilly . . . by the seaside . . . In short there is nothing here for a painter but the breakers — & sky — which have been lovely indeed and always varying.'

In spite of his dislike for the place he eventually put his sketches to use in a large Brighton scene, perhaps thinking it would enjoy the popularity of his other sea pieces. When it was exhibited at the Royal Academy in 1827 the reviewer for *The Times* described him as 'unquestionably the first landscape painter of the day,' but others voiced criticisms over its colouring and it failed once again to find a purchaser. This was partly due to Constable's uncompromising attitude to the subject. His painting defies conventional expectations by presenting Brighton less as a fashionable resort than as a fishing town. There are holidaymakers on the beach but it is hardly 'Piccadilly by the seaside' since the high winds and threatening weather would have driven most of them indoors. In their place he devotes his attention to those things he could admire — the breakers and the sky. When Fisher urged him to repaint the picture to 'let in sunshine' he was missing the point.

Constable's own health throughout this period was worsening. He was prey to rheumatism and to frequent bouts of anxiety and depression. He quarrelled with his Paris dealer, John Arrowsmith, with Fisher's solicitor, John Tinney (who had commissioned two small paintings from the artist but these were never completed) and even with Fisher himself. In an extraordinary letter to his friend dated 26 November 1825, he claimed that he was victimized on all sides: 'The publick is always more against than for us, in both our lots, but then there is this difference. Your own profession closes in and protects you, mine rejoices in the opportunity of ridding itself of a member who is sure to be in somebodys way or other.' Constable's paranoia was born from a keen sense of grievance, for as David Wilkie observed, he had brought honour to his country and he richly deserved to be a full Academician.

In spite of vigorous canvassing among his colleagues he lost out again in February 1828, this time to William Etty, whose mildly erotic paintings he later described as 'a revel rout of Satyrs and lady bums'. Constable's major exhibition picture of that year was *Dedham Vale* (p. 117), an elaboration upon the *plein-air* oil study he had made in 1802 (p. 47). Like the study it refers directly to Claude's *Landscape with Hagar and the Angel* (p. 12), and it has been plausibly argued that Constable intended it as a reply to those who had preferred Etty's nymphs and satyrs to his serious domestic landscapes. Constable would not have claimed to equal Claude, but he could at least declare his ambition to do for English scenery what Claude had done for the Roman *campagna*.

In the same year, Maria's father died leaving her £20,000, which relieved all the financial difficulties they had suffered. But Maria's health was a cause of continuing concern. In spite of her tuberculosis she gave birth to their seventh child in January, but never fully recovered her strength. She grew steadily weaker throughout the year and died on 23 November. Constable

was devastated and wrote to his friend, the portrait painter Pickersgill: 'my loss, though long looked for, now it has come, has overwhelmed me, a void is made in my heart that can never again be filled in this world . . . My dear departed angel died in my arms on Sunday morning.' The depth of his grief is often invoked to explain many of the stormier, more turbulent pictures of Constable's later years, like *Hadleigh Castle* (p. 119) or the small oil sketch of *Old Sarum* (p. 121). There is some justification for this since the engravings made after his work by David Lucas clearly employ chiaroscuro as a vehicle of sentiment. The mezzotint of *Weymouth Bay*, for example, is far more dramatic than the sketch on which it was based, and when he gave a proof of it to Leslie's wife, he added the lines by Wordsworth 'that sea in anger/and that dismal shoar.' 'I think of "Wordsworth",' he wrote 'for on that spot perished his brother in the wreck of the Abergavenny.' The happy associations of his Dorset honeymoon had been displaced by the grimmer recollections of a tragic shipwreck which took place in 1805.

Constable was finally and belatedly elected a Royal Academician on 10 February 1829. 'It has been long delayed,' he said, 'until I am solitary and cannot impart it.' Any remaining pleasure he felt was spoiled by Sir Thomas Lawrence, who told him he was fortunate to have been elected when there were historical painters on the list of candidates. Two months later he complained to Leslie that he was 'still smarting' from his election and 'in the height of agony' at the prospect of sending his picture of *Hadleigh Castle* to the exhibition. As a new Academician his work would fall under close, often unfriendly scrutiny; besides which he had previously become thoroughly acquainted with new or unfamiliar scenery before embarking on anything ambitious. He first sketched Hadleigh Castle, a remote and desolate location on the Thames estuary, in 1814. It impressed him with its 'melancholy grandeur', but he was preoccupied at the time with the agricultural landscape and chose not to work the subject up for the exhibition. In returning to it he may have intended to demonstrate to his colleagues once and for all that he deserved the status of an Academician. It was an exercise in 'sublime' landscape, the kind with which Francis Danby, his rival in the Academy election, had made his reputation; more specifically, ruined castles were closely associated with Turner, a far greater painter than Danby. When Turner was elected to the Academy in 1802 he presented it with a picture of *Dolbardern Castle* as his 'diploma piece', the formal proof of excellence required of every new Academician. Constable's *Hadleigh Castle* attempted to show that, like Turner, he could aspire to the 'higher walks' of landscape.

Constable's oppressive sky, which is more powerful in the full-size sketch (p. 119) than in the finished picture, may have expressed his feelings after Maria's death, but it was also consistent with the subject itself. In 1821, when he described the sky as the 'chief organ of sentiment', he was referring not merely to the artist's own emotions, but also to the associations of the place depicted. In the text accompanying the engraving of *Old Sarum* he wrote that 'sudden and abrupt appearances of light, thunder clouds, wild autumnal evenings . . . even conflicts of the elements [are appropriate] to heighten, if possible, the sentiment which belongs to a subject so awful and impressive'. Constable's landscape had always been one of sentiment and association, but hitherto they were largely personal; in some of his later work, such as *Old Sarum* or *The Cenotaph*, the associations are historical and public. In these he draws closer to Turner, who learnt from Reynolds that allusions and references of this kind were one means of creating an 'elevated' and demanding form of landscape.

In the last years of his life Constable became more concerned than ever to demonstrate the versatility, seriousness and expressive potential of his chosen art. He feared that his pictures alone would not accomplish this and decided in 1829 to issue a series of engravings after his works with an accompanying explanatory text. Turner had already attempted a similar enterprise, which he called his *Liber Studiorum*, and his example may have led Constable to think along similar lines. If so, he should perhaps have taken notice of the fact that it had been a commercial failure, and its purposes widely misunderstood. Constable's project, entitled *Various Subjects of Landscape, Characteristic of English Scenery, From Pictures painted by John Constable, R. A.*, was beset by difficulties and delays. He invested a great deal of time, money and energy in the scheme, exercising the closest possible control over his engraver, David Lucas. Nonetheless, only twenty-two prints were issued during his lifetime and the public response was negligible.

It may have met with indifference from most of his contemporaries but the *English Landscape* series is an invaluable guide to Constable's later attitudes and intentions. His introduction placed a heavy emphasis upon 'the CHIAROSCURO IN NATURE', which he had vigorously pursued in *Hadleigh Castle* and subsequently in *Salisbury Cathedral, from the Meadows* (p. 127). Without a mastery of the landscape's light and shadow it was impossible 'to render permanent many of those splendid but evanescent Exhibitions, which are ever occuring in the changes of external Nature,' and which he claimed was one of his leading aims. Constable selected examples for Lucas to engrave from the full range of his achievement, without making any distinction between the major exhibition pictures and the briefest of sketches. In consequence one becomes aware, for example, of how great a part marine subjects play in his work. As he wrote in the letterpress:

'Of all the works of the Creation none is so imposing as the Ocean; nor does Nature anywhere present a scene that is more exhilarating than a sea-beach.'

Elsewhere he discourses upon topics varying from 'the natural history . . . of the skies,' to the historical associations of his subjects, thereby revealing the depth and complexity of even the humblest motif. The preparation of *English Landscape* was a time-consuming process, but Constable continued to paint and to fulfil his other professional responsibilities. In January 1831 he was Visitor at the life class of the Royal Academy, charged with posing the model and instructing the students, and it may have been at this time that he was sketched by Daniel Maclise (p. 40), one of the most gifted of his young contemporaries.

In the major exhibited paintings of his later years the

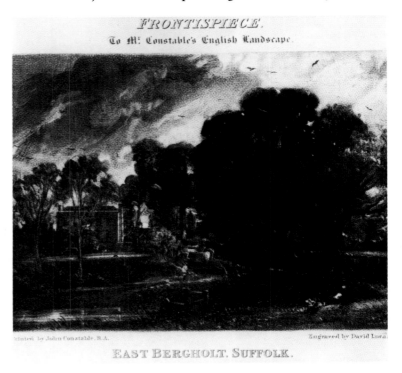

David Lucas: *Mezzotint after John Constable's The Paternal House and Grounds of the Artist*, 1829.

influence of Claude, which had been so strong, is less easily discerned. *The Valley Farm* (p. 135) of 1835 retains an overall compositional similarity to Claude's *Landscape with Hagar and the Angel*, but it has none of Claude's serenity or (in its present form) his freshness. *Salisbury Cathedral, from the Meadows* (p. 127), which had been planned during a visit to Fisher in 1829 and shown two years later, is another case in point. It is one of his most dramatic images, displaying 'the chiaroscuro in nature' in all its extremes, and as with the engraving after *Old Sarum*, nature's light and shadow are used to serve the sentiments and associations appropriate to the subject. Fisher's remark that 'the Church under a cloud' was the best subject Constable could take has led historians to conclude that these were partly political. Constable's political views had always been conservative but he became increasingly reactionary as he grew older, and fearful of social and constitutional change. He was alarmed by the emancipation of Catholics, by the repeal of the Test and Corporation Acts, and above all, by the spectre of electoral reform. Most historians now agree that the Reform Act of 1832 was a cautious piece of legislation which may actually have reduced the number of people entitled to vote, but Constable was convinced in 1831 that the Bill would 'give the government into the hands of the rabble and dregs of the people, and the devil's agents on earth, the agitators'. He and Fisher both believed that due to the union of Church and State, any threat to the constitution was also a threat to the Anglican faith. Salisbury Cathedral would be a convenient symbol of the beleaguered Church, the guardian of those threatened values to which they both adhered.

There are other details, however, such as the dog, the boatman and the cart, which were adapted, perhaps in a spirit of nostalgia, from his earlier Suffolk paintings; they render *Salisbury Cathedral, from the Meadows* a curious amalgam of public and personal meanings. Underlying them all is a reference to the most famous painting of Jacob van Ruysdael, his *Jewish Cemetery* (Detroit Institute of Arts). Ruysdael's work was important to the artist in this period; in 1832 he made a painstakingly exact copy of the *Winter* landscape (p. 15), then in the collection of Sir Robert Peel. It was loaned on the condition that the copy would differ from the original in some significant detail, and so he introduced a dog behind the principal figure. Like his earlier replica of Claude's *Landscape with a Goatherd and Goats* it was intended to be of permanent use to him, although as a rule he avoided winter scenes since they seem to have held funereal associations. Whilst copying the Ruysdael he was mourning the death of John Fisher who had died in France in August. He had contracted cholera during a trip to Boulogne, which, with a macabre irony, he had undertaken for his health. Constable wrote to Leslie, saying, 'I cannot tell how singularly his death has affected me,' and that his mind was 'in a fit state' to tackle a winter scene. When it was completed he showed it to his former studio assistant, Johnny Dunthorne; three days later his sadness over Fisher was compounded when Dunthorne himself died of heart disease at the age of 34. Constable was moved to record the melancholy event on the stretcher.

In spite of his election to the Academy, Constable's achievement continued to go largely unrecognized. He even witnessed the supposedly accidental rejection of his *Water-Meadows near Salisbury* (p. 123) by the organizing committee of the annual exhibition. He was frequently plagued with poor health and in 1832 his rheumatism made it difficult to work on a large canvas. He may therefore have chosen to exhibit *The Opening of Waterloo Bridge* (p. 131) at the Academy because it had been under way for many years and required little finishing. He worked largely with the palette knife, which as Reg

Daniel Maclise: Pencil sketch of Constable painting, *c.* 1831.

Gadney pointed out, was less painful to hold and manipulate than a brush. His friend Stothard thought the picture too unfinished for the exhibition, whilst Leslie regarded it as a 'glorious failure', spoilt by 'the vagaries of the palette knife'. A twentieth-century audience, used to a lively paint surface, is more prepared to see the virtues in Constable's handling, even if they are virtues which arose in this case partly from necessity.

Constable's need to communicate his purposes to an audience that had so consistently misunderstood him survived the fiasco of the *English Landscape* scheme. Between 1833 and 1836 he delivered ten lectures on the history and theory of landscape painting at Hampstead, Worcester and the Royal Institution. He explained his motives in a letter to David Wilkie: 'I have long been "possessed" of feeling a duty on my part — to tell the world that there is such a thing as Landscape existing with "Art" — as I have in so great measure failed to "show" the world that it is possible to accomplish it.' In this, as in other things, Constable was employing a strategy that had also been used by Turner, who devoted one of his perspective lectures at the Royal Academy to 'Backgrounds' as a means of introducing landscape onto his agenda. They both argued that landscape painting, though it began as 'the child of history' (to use Constable's words) proceeded to grow in power until 'from being the humble assistant it became the powerful auxiliary to that art which gave it birth'. From there it grew to stand on its own merits, and by implication to equal history painting in its status and achievements.

He translated these arguments into pictorial form in *The Cenotaph* (p. 137), a painting that is both didactic and valedictory. By taking Sir George Beaumont's memorial to his friend Reynolds as a subject, he could combine their names in the catalogue of the last Royal Academy exhibition to be held in Somerset House. It is a public tribute to the part they played in fostering and encouraging the British School of painting. He flanks the cenotaph itself with non-existent busts of Raphael and Michelangelo, the artists to whom Reynolds repeatedly appealed in his *Discourses* as models of the 'Grand Style' in art. The meanings imparted by the painting are impeccable in their dignity and complexity, but they are delivered by means of landscape, a supposedly inferior genre. Constable celebrates the British School, but in a way that leaves no doubt about the centrality of landscape in any account of its achievements. On another level the picture discharges a personal debt of gratitude to Reynolds and Beaumont, both of whom had materially shaped his career.

Constable witnessed the Royal Academy's move from Somerset House but he did not live long enough to see the first exhibition held in their new premises in the National Gallery. He had been preparing a view of *Arundel Mill and Castle* (p. 139) for some time, based on oil sketches made during a visit to his friend and namesake, George Constable, who lived in Sussex. He was still working on the painting on 31 March, the day of his death. Although he had suffered ill health for many years his death was unexpected and, from Leslie's account, all the indications are that he died of a heart attack.

Leslie immediately took charge of Constable's affairs and looked after the interests of his family. He helped to manage the estate and to secure the best possible prices at the auction sale held in 1838. In the process he discovered that Constable was becoming famous enough to attract the attention of forgers and swindlers, including, he claimed, George Constable, the Sussex brewer with whom the painter had become friendly. Constable's documented and authenticated *œuvre* has been surrounded by doubtful works ever since, and his family,

who were vigilant where rumours of forgery were concerned, unwittingly added to the problem. His son Lionel was a talented but reticent man who worked in a style that was easily mistaken for that of his father. *Near Stoke-by-Nayland* (p. 42), for example, was once regarded as a very fine small picture by John Constable; since 1978 it has been reattributed to Lionel.

Besides protecting his friend's reputation from imposture, Leslie began to collect material for his biography, sifting through Constable's notes and correspondence and canvassing widely for reminiscences. Commentators have always pointed out the degree of cosmetic attention he devoted to his subject's personality, omitting the acerbity and intolerance that often marked Constable's maturity, but of equal importance is his partial account of the works themselves. Leslie, like many of his contemporaries, was perplexed by the later paintings in particular, and attempted to explain their extraordinary handling as the result of over-zealous naturalism. He argued that Constable's pursuit of chiaroscuro and 'that brightness in nature which baffles all the ordinary processes in painting', drew him 'by degrees into a peculiar mode of execution, which too much offended those who were unable to see the look of nature it gave at the proper distance'. The idea that an intractable technique would somehow look 'natural' at the correct distance was also frequently advanced in desperation to explain Turner's handling, but in both cases it was a non-starter. Constable even requested that his pictures should be hung in such a way as to permit close scrutiny of their surface. Leslie was unable to acknowledge that many of his later paintings were a departure from the earlier naturalistic ideals.

He nonetheless provided an explanatory framework with which to approach the paintings and encouraged the growth of Constable's reputation. Constable now has no shortage of admirers and commentators, and towards the end of his life, he seems to have been resigned to such posthumous fame, as he explained in the introduction to *English Landscape*: 'the rise of an artist in a sphere of his own must almost certainly be delayed; it is to time generally that the justness of his claims to a lasting reputation will be left; so few appreciate any deviation from a beaten track.' He would have been gratified to learn that his words were prophetic.

Lionel Bicknell Constable: *Near Stoke by Nayland*, c. 1850.

THE PLATES

Dedham Church and Vale, 1800

Pen, ink and watercolour, 34.6 × 52.7 cm. Whitworth Art Gallery, University of Manchester

Dedham Church and Vale is one of four immature but highly finished watercolours that together present a broad panorama of the Stour Valley from west to east and thus summarize a great deal of Constable's later Suffolk subject-matter. He presented them to Lucy Hurlock, whose marriage would take her away from the countryside in which she grew up, and intended them as a permanent reminder of her home, hence their precise topography and painstaking attention to detail. The watercolour reveals the limits of Constable's skills at this time, for he clearly had difficulties with the transition from the foreground to the middle distance, whilst the corners are conspicuously and awkwardly 'filled in'.

The Hurlock family were close friends of the Constables and it was through Lucy's father, the Revd Brooke Hurlock, curate of Langham, that Constable was introduced to Dr John Fisher, the Bishop of Salisbury. The viewpoint Constable employs is from highground at Langham, below Brooke Hurlock's church, and looks towards Dedham, where the Hurlock family lived, and whose church tower is conspicuous in the middle distance. The estuary at Harwich closes the view.

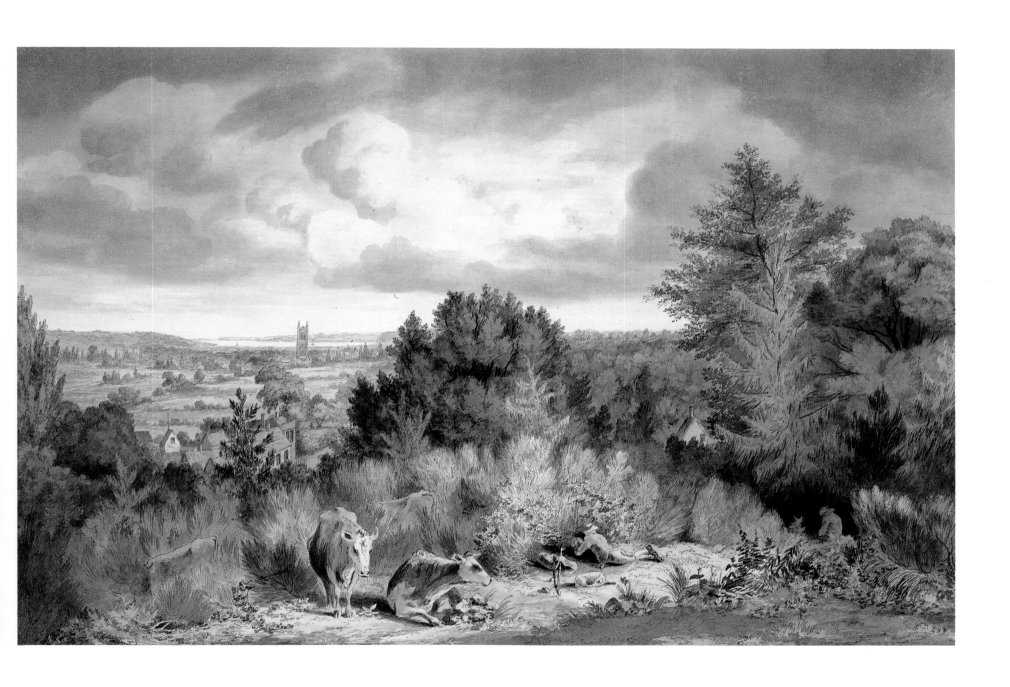

Dedham Vale, 1802

Oil on canvas, 43.5 × 34.4 cm. Victoria and Albert Museum, London

The year 1802 was an important one for Constable: for the first time one of his landscapes was accepted for exhibition at the Royal Academy. This undoubtedly fuelled his ambition and enthusiasm, but he was disparaging about the other works on show, claiming 'There is little or nothing in the exhibition worth looking up to – there is room enough for a natural painture.' A visit to Sir George Beaumont's collection convinced him that 'there is no easy way of becoming a good painter', but more significantly it provided him with a plan of action, for he announced: 'I shall shortly return to Bergholt where I shall make some laborious studies from nature – and I shall endeavour to get a pure and unaffected representation of the scenes that may employ me.'

During the summer and autumn of 1802 Constable did execute many *plein-air* studies around East Bergholt, including *Dedham Vale*, but after his visit to Beaumont's collection he made them with Claude in mind. The *Landscape with a Goatherd and Goats* (p.13) was widely believed to have been painted before nature and may have served him as a model of 'natural painture', whilst Claude's *Landscape with Hagar and the Angel* actually provided him with a pictorial framework around which to organize his *Dedham Vale*. Although it was produced for a different purpose, it is interesting nonetheless to compare this confident oil study with the flawed structure of his earlier watercolour (p.45).

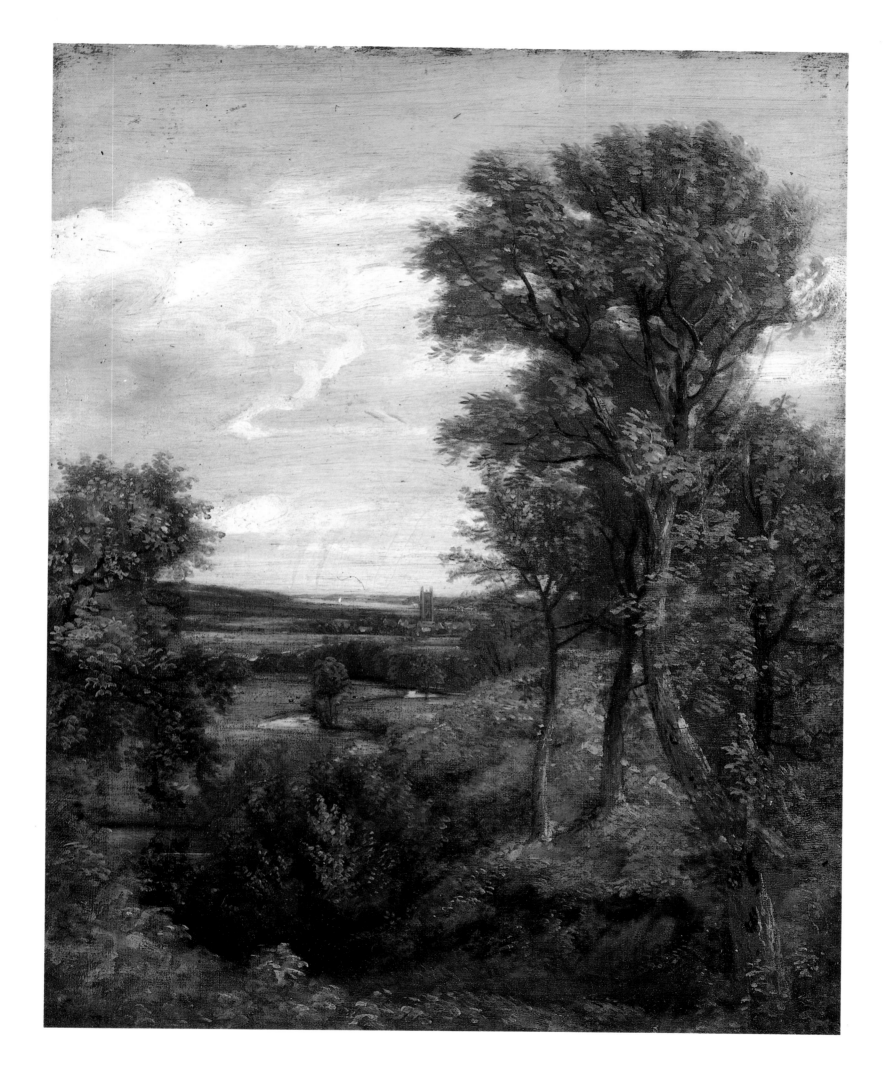

Warehouses and Shipping on the Orwell at Ipswich, 1803

Watercolour and pencil, 24.5 × 33.1 cm. Victoria and Albert Museum, London

This watercolour, which is inscribed on the back '5 Oct – 1803 Ipswich', was painted whilst Constable visited his friend, George Frost, whom he had known since 1797. Frost was thirty years older than Constable and earned his living as a clerk in a coaching office, but like Constable's other friend, John Dunthorne, he was also an amateur painter with a solid local reputation. Frost evidently worked alongside Constable whilst he made this drawing, for he produced an identical composition himself. At this stage he had a considerable influence upon Constable: he was an avid collector of Gainsborough, whom he imitated in his drawings, and he encouraged the younger artist to do likewise. Constable also acquired at least forty-one of Frost's unsigned drawings, thereby creating problems of authorship and attribution since they often resemble each other so closely. The confusion tends to be greatest in woodland subjects where their attempts to mimic Gainsborough's 'shorthand' notation of foliage provides a common denominator, but even here, on the Orwell, Frost and Constable are stylistically close.

'His Majesty's Ship "Victory", Capt. E. Harvey, in the memorable Battle of Trafalgar between two French Ships of the Line', 1806

Watercolour, 51.6 × 73.5 cm. Victoria and Albert Museum, London

Constable was a talented marine painter but this large watercolour with its public theme and strongly patriotic sentiments is untypical of his sea pieces, which are normally coastal views. Leslie 'domesticates' the work by suggesting that it was painted after Constable heard 'an account of the battle from a Suffolk man who had been in Nelson's ship', but any local connection, if true, is of secondary importance. It was, above all, an attempt to capitalize on Nelson's victory. Sea pieces and battle pictures were a long-established genre in England, extending back to the Third Dutch War (1672–3) and the work of the Willem van de Veldes (Elder and Younger). They were also judged with a fine eye for nautical detail. Constable, who was undoubtedly aware of this, had studied the *Victory* at close hand at Chatham in 1803 whilst travelling on the East Indiaman, *Coutts*. He may nonetheless have felt insecure within this demanding and unfamiliar genre and this might explain why he chose the less conspicuous medium of watercolour.

Windermere, 1806

Pencil and watercolour, 20.2 × 37.8 cm. Fitzwilliam Museum, Cambridge

According to C. R. Leslie, Constable claimed that 'the solitude of mountains oppressed his spirits', and consequently his Lake District subjects were undervalued for many years. The remark may have been authentic but it was made much later in Constable's career, for in 1806 there is every indication that he approached the scenery of Cumberland and Westmoreland with great commitment, producing an enormous body of work, largely in watercolour. At East Bergholt he had previously made the landscape study in oils a significant part of his practice, but in Lakeland watercolour was more convenient, given the terrain and the unpredictable climate. The painstaking descriptive work of the East Bergholt studies is replaced by an impressive striving after fleeting meteorological conditions, or 'grand and solemn effects of light', as Leslie termed them. The Lakes were a conventional choice for a sketching tour and seem to have been suggested by Constable's maternal uncle, David Pike Watts, who also financed the excursion. Judging by his dated drawings he spent at least seven weeks there (from 1 September to 19 October), probably in the belief that his repertoire of sketches would produce a saleable exhibition picture.

'A church porch' (The Church Porch, East Bergholt), c. 1809

Oil on canvas, 44.5 × 35.9 cm. Tate Gallery, London

In his watercolour of East Bergholt church (p.59) Constable was concerned simply with describing his subject, but in this, the first oil painting he is known to have exhibited (in 1811), he introduces more complex meanings. As Michael Rosenthal has suggested, the picture is full of *vanitas* symbolism: the setting sun on a late summer's evening, the three generations represented in the figures, and the sundial are all intended to remind the viewer of the passage of time and of his or her mortality, whilst the Church offers the hope of salvation. Constable lent the picture to Ann Leslie, his biographer's sister, to copy in 1830 and tried to hint at some of its symbolism: 'The motto on the dial', he wrote, 'is "Ut umbra, sic vita" ' (Life is as a shadow). Constable addresses the issue of death and human achievement elsewhere in his work, most notably in *The Cenotaph* (p.137) but here the treatment is rather conventional, drawn from a literary and pictorial tradition of graveyard philosophizing which included Gray's *Elegy*, which Constable had illustrated, and Poussin's painting *Et in Arcadia Ego* (Louvre, Paris). As an exhibited work, and one with serious moral intentions, the painting is remarkable for its small scale and sketchy finish.

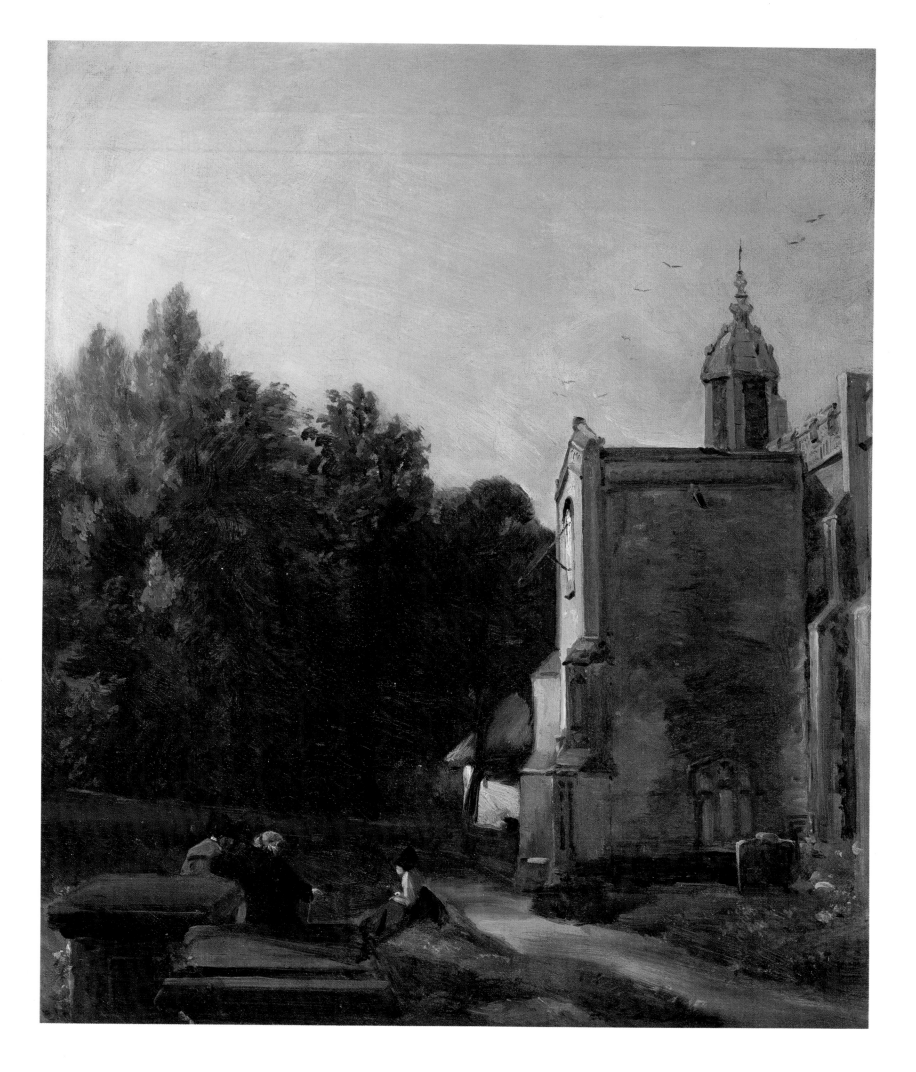

Flatford Mill from the Lock, c. 1811

Oil on canvas, 24.8 × 29.8 cm. Victoria and Albert Museum, London

In November 1811 Constable wrote that he had 'tried Flatford Mill again, from the lock' and he is known to have studied the site intensively for over a year. This small oil sketch is one of a number, either on canvas or on paper laid on board or canvas, which take Flatford Mill or Flatford Lock as their subjects. In this instance Constable's technique, which involves painting at times with heavier discrete touches and elsewhere with a partially or semi-laden brush, allows the warm brown areas of ground to show through. In December 1810, Constable's uncle, David Pike Watts, showed some interest in acquiring a finished painting after Constable's sketches but he insisted that it should 'be worked up to bear a close eye as a Cabinet [picture]'. The picture he eventually painted which drew on all these various studies of Flatford Mill is entitled *A Watermill* (on loan to the Corcoran Collection, Washington, DC) but it is too large to be described as a cabinet picture and was clearly not painted for Watts.

Michael Kitson first pointed out that the composition of these sketches, with their heavy dependence upon linear perspective, was derived from the two seaport subjects by Claude in the collection of John Julius Angerstein. These were well known to Constable and he made use of their pictorial framework on many occasions in the second decade of the century. Despite his fondness for Claude's pastoral subjects he told the Hampstead Literary and Scientific Society in 1833 that Claude 'is nowhere seen to greater advantage than in his seaports'.

East Bergholt Church, 1811

Watercolour, 39.7 × 60 cm. The Lady Lever Art Gallery, Port Sunlight

Constable rarely painted purely architectural subjects but East Bergholt church had a particular local significance and he is known to have produced a number of watercolours of this subject as well as the oil painting of the church porch (p.55). This drawing once existed in two versions; the first seems originally to have been given to his mother, perhaps as early as 1806. It was she who suggested in a letter of 18 January 1811, that Constable should make a fair copy of the work and present it to Dr Rhudde, the Rector of East Bergholt and the maternal grandfather of Maria Bicknell, with whom Constable had fallen in love. She correctly anticipated that any serious opposition to her son's marriage would come from Rhudde rather than Maria's father. Constable's friend John Dunthorne, a well-known atheist who profoundly disliked the rector, was persuaded to write an ingratiating dedication which Mrs Constable fixed upon the back. It reads: 'A South East View of East Bergholt Church in the County of Suffolk. a Drawing by J. Constable Esqr. and presented in testimony of Respect to the Revd. Durand Rhudde.D.D. the Rector. Feby 25 1811.' If Constable thought his gift would secure a little goodwill he was mistaken – Rhudde outmanœuvred him by sending a banknote the following month.

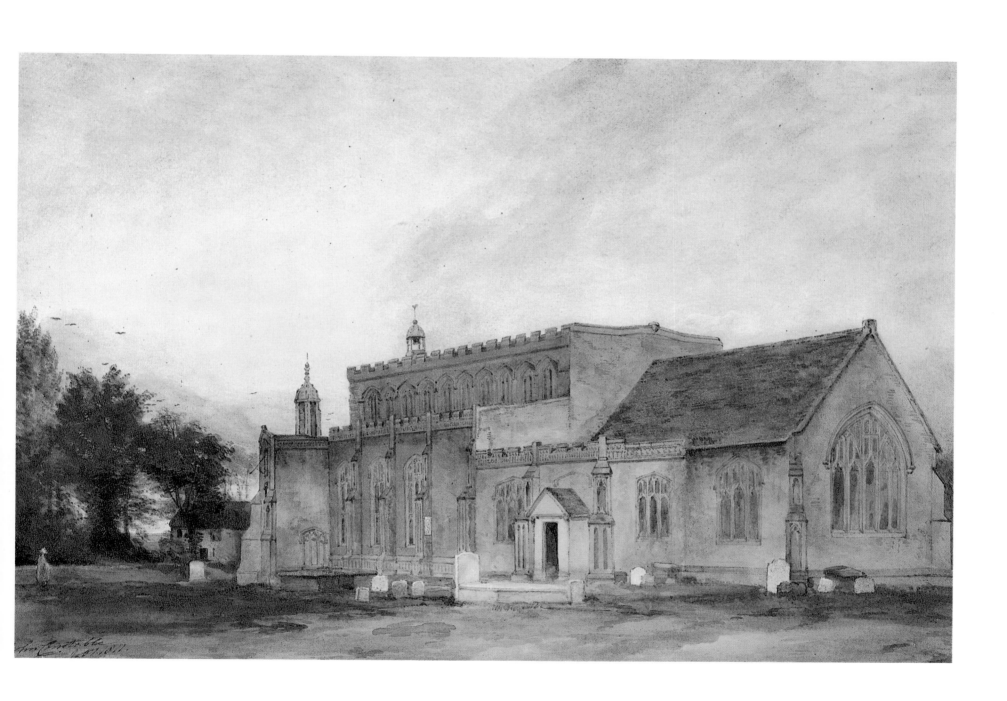

Study for Stratford Mill, 1811

Oil on wood, 18.3 × 14.5 cm. Private collection

This small oil sketch of Stratford Mill was made in the open air on 17 August 1811 and is unusual among the Stour sketches of this period for the degree of attention devoted to the figures, three of whom are young boys shown fishing at the water's edge. It was not, however, until 1820 that Constable returned to the study and adapted it for use in an important finished picture. Following the great success of *The White Horse* at the Royal Academy in 1819, he sought to consolidate his reputation with another six-foot painting on a comparable theme. He extended the composition of the sketch to the right to include a view of the river, a barge and the water-meadow opposite the mill. The completed picture, entitled *Stratford Mill*, had few of the personal associations common to so many of Constable's Stour Valley scenes and was his only major version of the subject, but he considered it nonetheless to be among his most important achievements.

It is not altogether clear why he returned to the sketch after an interval of nearly nine years, but he may have considered the boys fishing to be a likeable, albeit conventional episode which would recommend the painting to the Academy public. Sir George Beaumont certainly approved, observing that one of the boys was 'undergoing the agony of a bite'. C. R. Leslie believed that *Stratford Mill* had 'more subject' than the *White Horse*, but by 'subject' he seems to have meant 'anecdote' for the primary subject of the *White Horse* was the commercial navigation of the river.

According to the engraver David Lucas, Constable also expected his audience to read and understand the 'natural history' of the painting, some of which is clearly present in the sketch. He explained to Lucas that 'the principal group of trees being exposed to the currents of wind blowing over the meadows continually acting on their boles inclines them from their natural upright position and accounts for their leaning to the [left] side of the picture.'

Dedham Vale: Morning, 1811

Oil on canvas, 78.8 × 129.5 cm. Private collection

Constable told his engraver, David Lucas, that 'this picture cost him more anxiety than any work of His before or since that period in which it was painted. that he had even said his prayers in front of it.' It is easy to understand his nervousness, for *Dedham Vale: Morning* was probably his largest exhibition picture to date and one for which Constable had thoroughly and carefully prepared with a series of sketches and studies. As such it represented a clear attempt to impress his Royal Academy colleagues and public with his 'natural painture'.

It was probably the most expansive Suffolk landscape he had painted, for the view looks west from the junction of Fen Lane and the Flatford–East Bergholt road, along the Stour Valley to include the three churches of Dedham (on the left), Langham (in the centre, on the hills) and East Bergholt (on the right). According to his confidant in Academy matters, Joseph Farington, Constable heard that the picture was poorly hung in the exhibition, and concluded 'that it was a proof that He had fallen in the opinion of the Members of the Academy'. As usual, Farington offered encouragement and reassurance, but the picture seems nonetheless to have gone largely unnoticed. Its virtues were simply too subtle, for although it does appear distinctive and ambitious when judged alongside Constable's previous work, on the crowded walls of the exhibition rooms in Somerset House it would fail to stand out from its neighbours.

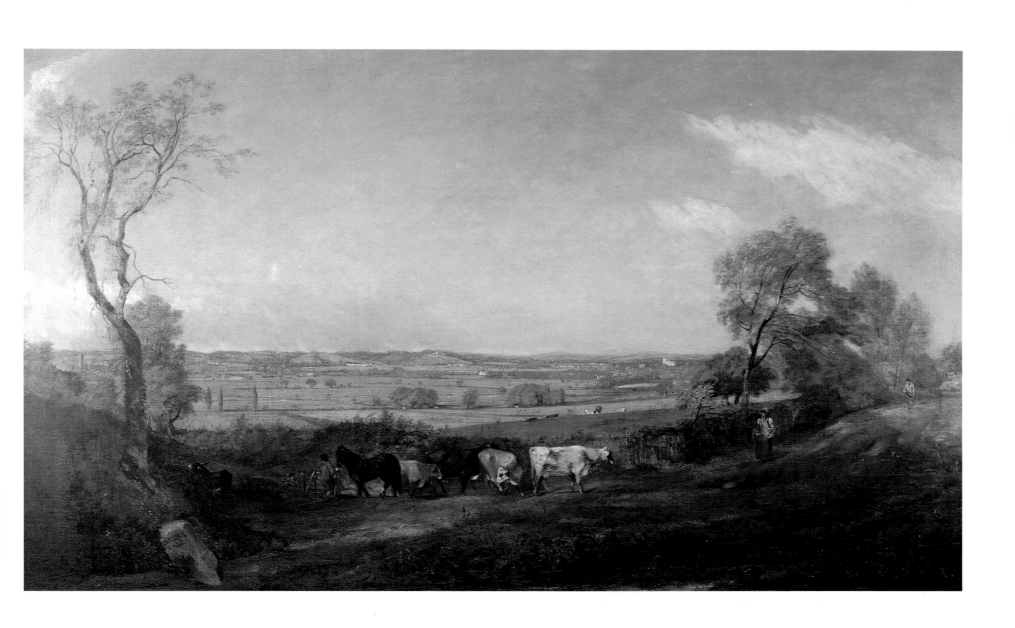

Landscape: Boys Fishing, 1813

Oil on canvas, 101.6 × 125.8 cm. National Trust, Fairhaven Collection, Anglesea Abbey

Constable's close friend, John Fisher, wrote a revealing and witty letter to the artist having seen this painting at the Royal Academy in 1813. 'I like only one better,' he wrote, '& that is a picture of pictures – the Frost of Turner [*Frosty Morning*, p. 27]. But then you need not repine at this decision of mine; you are a great man like Bounaparte and only beaten by a frost –.' Constable sat next to Turner at the Academy Dinner in 1813 and was much impressed by his 'wonderful range of mind', so he may have been flattered by the comparison, even though he came off second best.

The authenticity of this picture has recently been questioned, due to the discrepancies between the passages of high finish and the cruder treatment of sections of the foliage and path. Whatever its faults, they also seem to have been present in the picture which Constable's uncle, David Pike Watts, saw at the British Institution in 1814. He wrote of its 'Unfinished Traits' and asked 'Will any Person voluntarily prefer an imperfect Object when he can have a more perfect one?' From his response Constable was obviously fed up with his uncle's interference, for he replied that 'the picture has become the property of Mr. Carpenter who purchased it this morning. *He is a stranger and purchased it because he liked it* [italics mine].' James Carpenter, the purchaser, later published C. R. Leslie's biography of the artist.

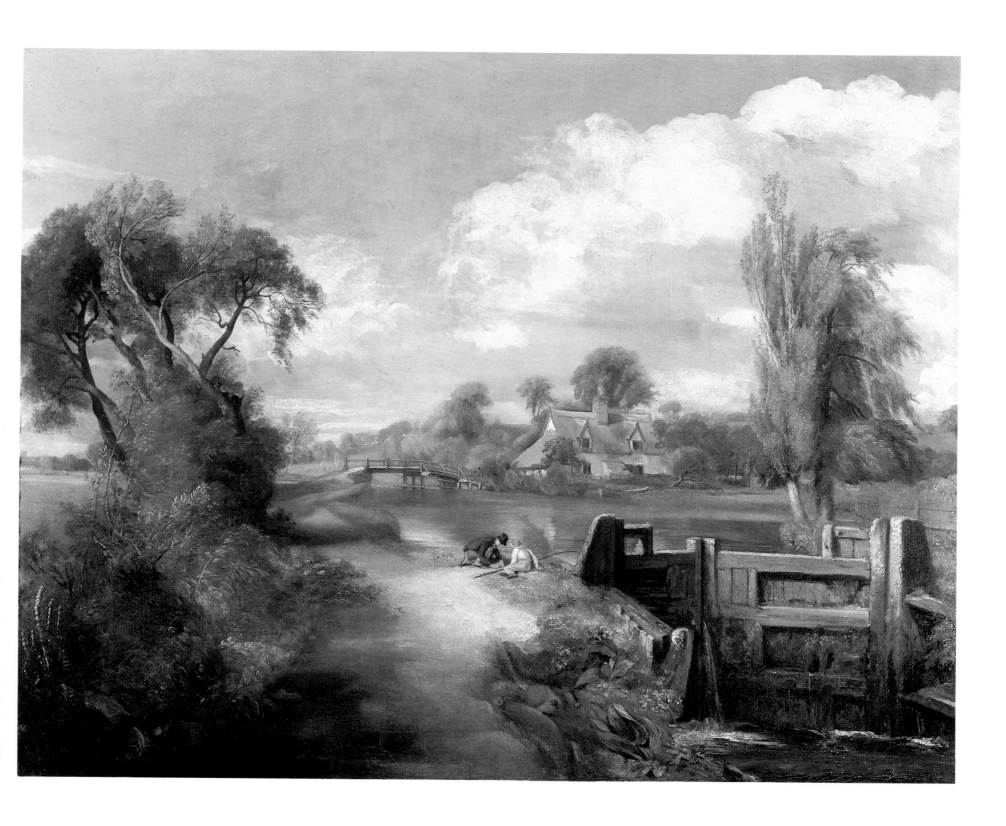

The Mill Stream, c. 1814

Oil on canvas, 71.1 × 91.5 cm. Ipswich, Museums and Galleries

Constable painted Willy Lott's cottage and the mill stream at Flatford on numerous occasions, the most famous being the *Hay-Wain* of 1821 (p. 93). Here the view is from the parapet behind Flatford Mill, to the right of the position he adopted for the later, more celebrated picture. Leslie was the first to point out that the agitation of the water in the foreground was due to the action of the mill wheel as it is fed by the stream; the ferry on the left operated through a channel to the far bank of the Stour, a point from which Constable made further studies and paintings of the cottage, most notably the *Valley Farm* of 1835 (p. 135). *The Mill Stream* is based on a small oil sketch now in the Tate Gallery that was probably executed around 1810–11; like other Flatford sketches of those years it is organized around the perspectival model of the Claude seaport paintings. As many commentators have pointed out the figures or staffage within the picture recur in many of Constable's later paintings, including the late *Valley Farm*.

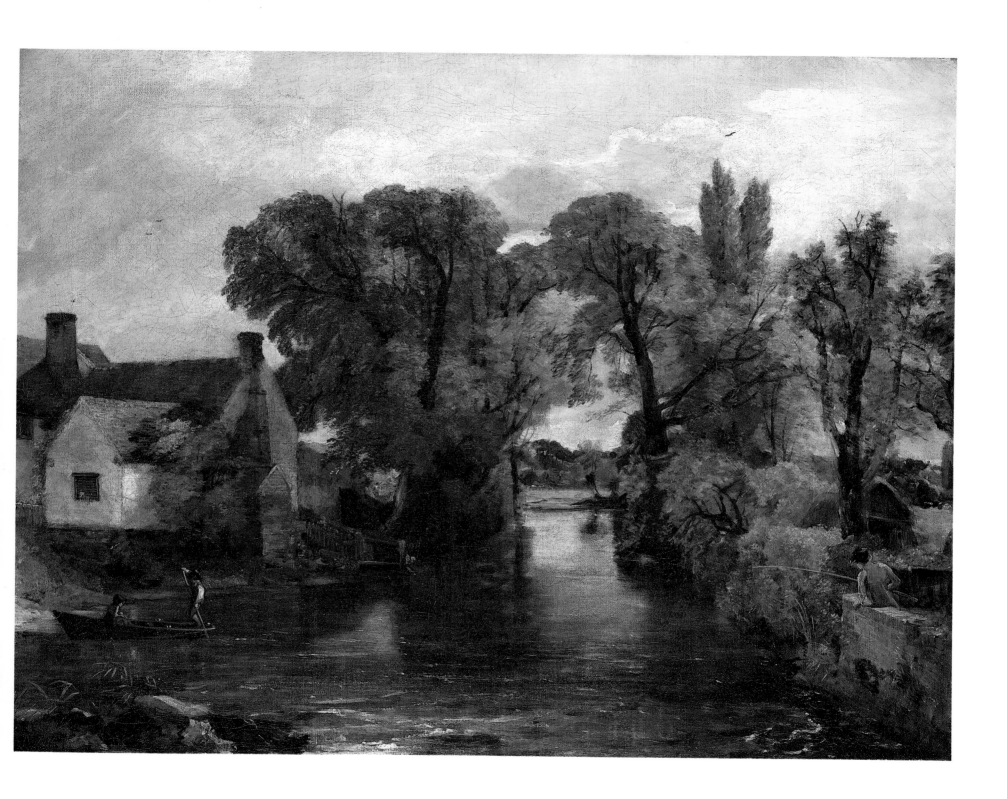

Landscape: Ploughing Scene in Suffolk (A Summerland), 1814

Oil on canvas, 51.4 × 76.8 cm. Private collection

John Allnutt, a wine merchant who lived in Clapham, owned two versions of this composition. He bought this one at the British Institution in 1815 but was worried by the sky and paid another landscapist, John Linnell, to repaint it. Dissatisfied with the effect of Linnell's changes, he asked Constable to restore the original sky but reduce the dimensions of the work to match those of another painting by Augustus Wall Callcott, with which he wanted to pair it. Rather than cut the painting down Constable produced another, smaller version for which he would accept no payment. It might be imagined that Allnutt's treatment of the picture would have offended the artist, but the original purchase was such a boost to Constable's flagging morale that he remained grateful to Allnutt despite his eccentricities.

The alternative title of the work, *A Summerland*, was given to David Lucas's engraving after the picture. It refers to land ploughed and harrowed in the spring but left fallow over the summer in preparation for the sowing of winter wheat. The landscape and the main ploughing team were taken from two pencil sketches Constable made in his 1813 sketchbook (p.28), but the ploughmen, who now provide the main subject of the picture, seem to have been introduced quite late in the development of the composition: in February 1814, he wrote to his friend John Dunthorne telling him 'I have added some ploughmen to the landscape from the park pales which is a great help.' Constable drew attention to their labour in the Royal Academy catalogue, where the entry for his picture was accompanied by two lines from one of his favourite poems, the *Farmer's Boy* by Robert Bloomfield:

> But unassisted through each toilsome day,
> With smiling brow the Plowman cleaves his way

Exhibitors had been allowed to quote verse in the catalogue since 1798, but this was the first time Constable had taken advantage of the opportunity. In so doing he drew comparisons between his work and the tradition of *georgic* poetry which took rural labour for its subject.

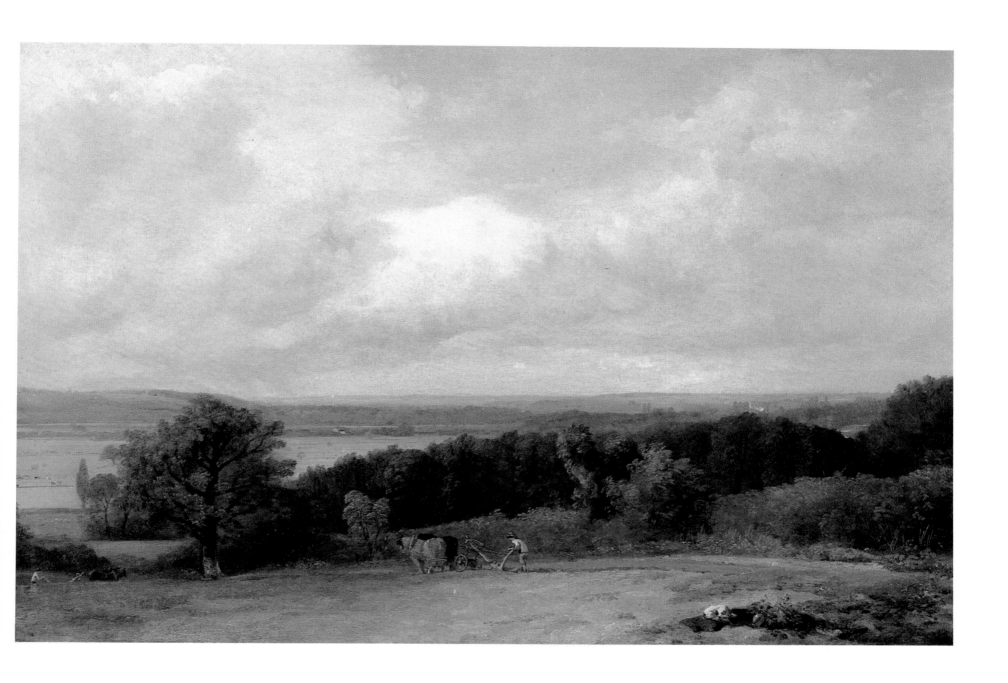

View of Dedham, 1814

Oil on canvas, 55.3 × 78.1 cm. Museum of Fine Arts, Boston, Massachusetts

Constable was commissioned to paint the *View of Dedham* largely as a result of his family's contacts within Suffolk society. His patron was Thomas Fitzhugh, Deputy Lieutenant and High Sheriff of Denbighshire, who was to marry Philadelphia, the daughter of Peter Godfrey, lord of the manor of East Bergholt. The Godfreys, who knew the painter's family well, were enthusiastic supporters of Constable's art. The picture was intended as a wedding present from Fitzhugh to his bride, and presumably a reminder of her parental home. In that respect it recalls the earlier *Dedham Church and Vale* (p. 45) painted for Lucy Hurlock in 1800; both contain panoramas of the Stour Valley but whereas the figures in the watercolour are an afterthought and incidental to the landscape, the *View of Dedham* manages to balance the demand for accurate topography with imagery detailing the working life of the Suffolk countryside. Constable pursued similar aims in his painting of *A Summerland* (p. 69), and as in that scene the viewpoint adopted is just outside the parkland belonging to the Godfreys.

The two paintings represent stages in the agricultural year: in the first, the land is being prepared to lie fallow, whereas in the *View of Dedham*, the labourers are shovelling out manure for ploughing into the fields before the sowing of winter wheat. The two would seem to form a natural pair, but Constable seems to have thought that the best companion for the *View of Dedham* was his *Boatbuilding* scene (p. 73) since he showed them together at the Academy in 1815. It has even been persuasively argued that the two pictures were painted concurrently – that he worked before nature on the *View of Dedham* in the mornings and on the *Boatbuilding* in the afternoons.

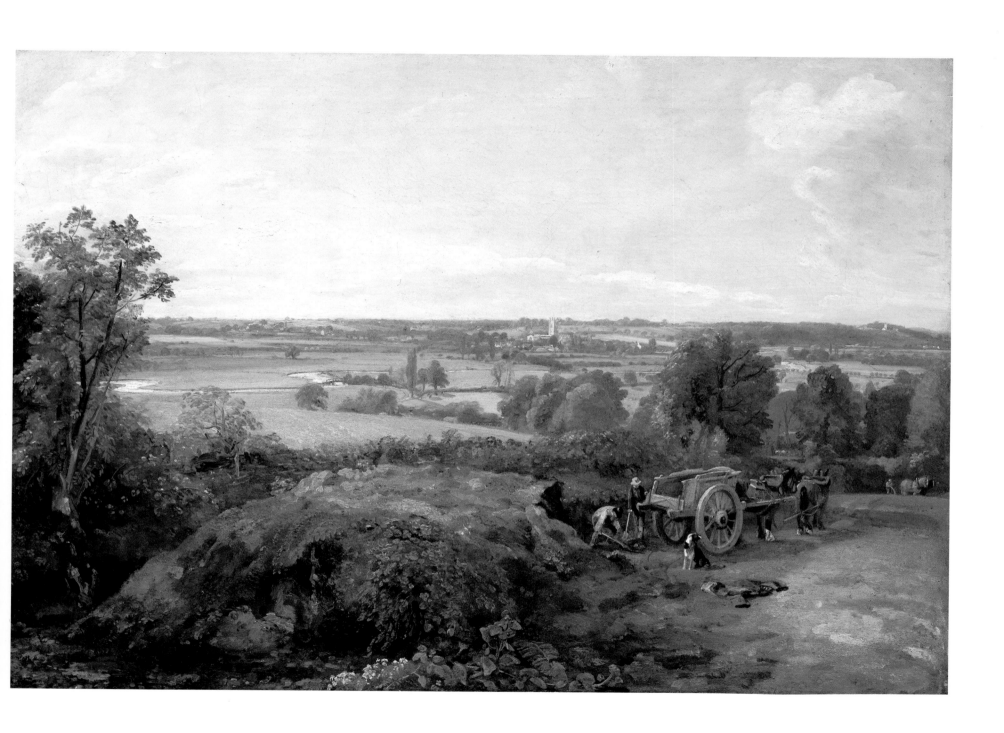

Boatbuilding, 1814

Oil on canvas, 50.8 × 61.6 cm. Victoria and Albert Museum, London

Many of Constable's most famous subjects are intimately bound up with the possessions and business interests of his father. Golding Constable was a prosperous corn merchant, whose activities included a well-organized shipping operation. Corn ground at Flatford Mill was carried down the Stour in his own horse-drawn barges to his wharf on the estuary, and from there taken to London. The barges naturally required repair and replacement, and for this purpose Constable's father maintained a dry dock near Flatford Mill. Constable's painting is based partly upon a pencil drawing made on 7 September in his 1814 sketchbook, although he departs from the sketch by reorganizing the figures in such a way as to demonstrate a sequence of stages in the construction of a barge.

According to C. R. Leslie, the picture was 'one which I have heard him say he painted entirely in the open air'. This is unlikely to have been wholly true, given the thoughtful and deliberate rearrangement of the figures, but there is no reason to doubt that most of the landscape was indeed painted before nature, even though the converging perspective of the dry dock, the background tree and the placing of the workmen corresponds very closely to Claude's famous seaport with *The Embarcation of St Ursula*, then in the Angerstein collection. This was not the first time he had adapted a Claudian schema within a *plein-air* painting: he had done precisely the same thing in his *Dedham Vale* of 1802 (p. 47). Constable is known to have studied Claude's *St Ursula* in July 1814 following a conversation with Joseph Farington in which they discussed his prospects of being elected an Associate of the Royal Academy. Farington suggested that a higher degree of finish in his exhibited pictures might improve his chances and recommended that he should take a lesson from Angerstein's Claudes. *Boatbuilding* was also a painting that offered Constable a rare opportunity to produce a Suffolk shipping subject with qualities of 'business and bustle' comparable to those he admired in Claude's seaports.

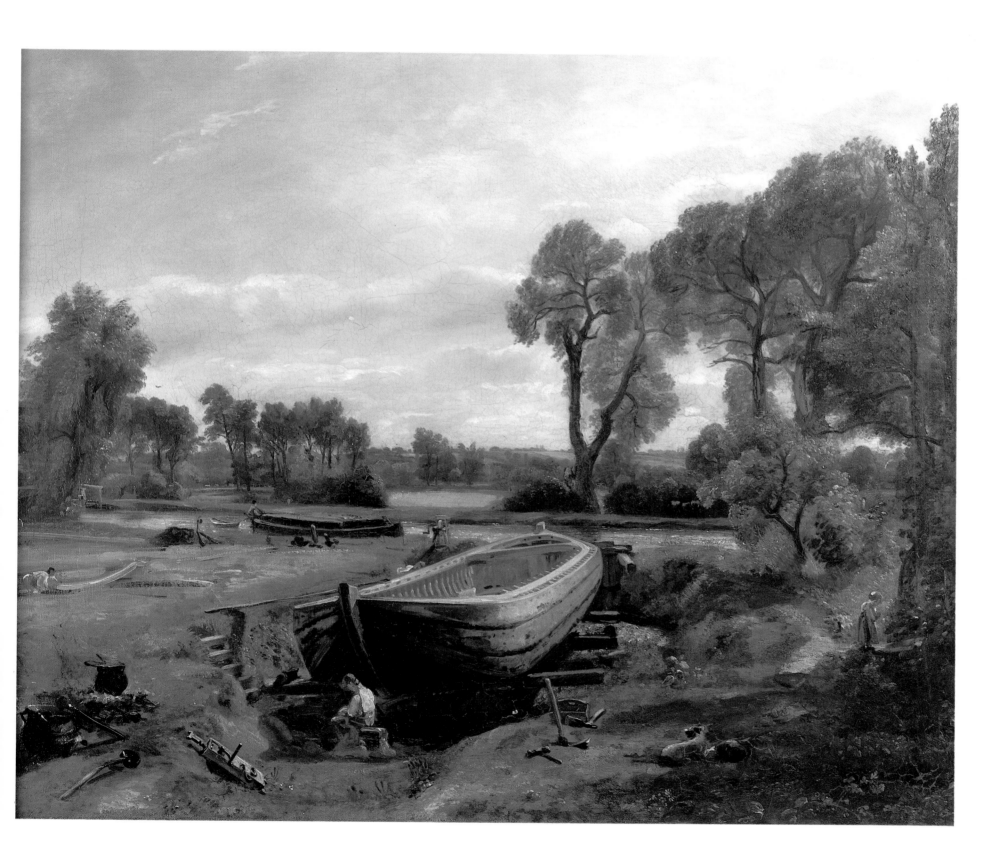

Golding Constable's Flower Garden, 1815

Oil on canvas, 33 × 50.8 cm. Ipswich, Museums and Galleries

Constable's views over the kitchen and flower gardens behind his parents' house at East Bergholt are among the most important of his earlier paintings. They are small in scale but contain an astonishing amount of topographical, agricultural and even meteorological information. They demonstrate clearly what Constable had in mind when he declared thirteen years previously that he would pursue a 'natural painture'. The view is taken from an upstairs window at the back of the house and, not surprisingly (for it allowed him to paint from nature in the comfort of home), Constable had depicted it many times. On the first known occasion, in about 1800, he left out the gardens altogether, perhaps thinking they were too banal, but by 1815 his naturalism demanded such particularity of detail.

The two oil paintings of the kitchen and flower gardens were neither exhibited nor engraved, although Constable did produce an elaborate pencil drawing combining both views (p. 7) which may have been shown at the Royal Academy. In the drawing, which was almost certainly made in 1814, the field in the middle distance has been partly ploughed in preparation for the sowing of winter wheat; the following summer was a glorious one and Constable's two paintings produced then record the marvellous harvest of that year. Michael Rosenthal has pointed out that although the scenes are adjacent, the pictures represent different stages in the life of the landscape: the *Flower Garden* was begun first, before harvesting got under way, and the *Kitchen Garden* painted later, since there is a gang of reapers at work, just visible near his father's windmill on East Bergholt Common. Different times of day are also recorded: from the evidence of the shadows the *Flower Garden* is an evening scene, whilst the *Kitchen Garden* is a morning picture. Together the paintings present his father's lands as the epitome of good husbandry.

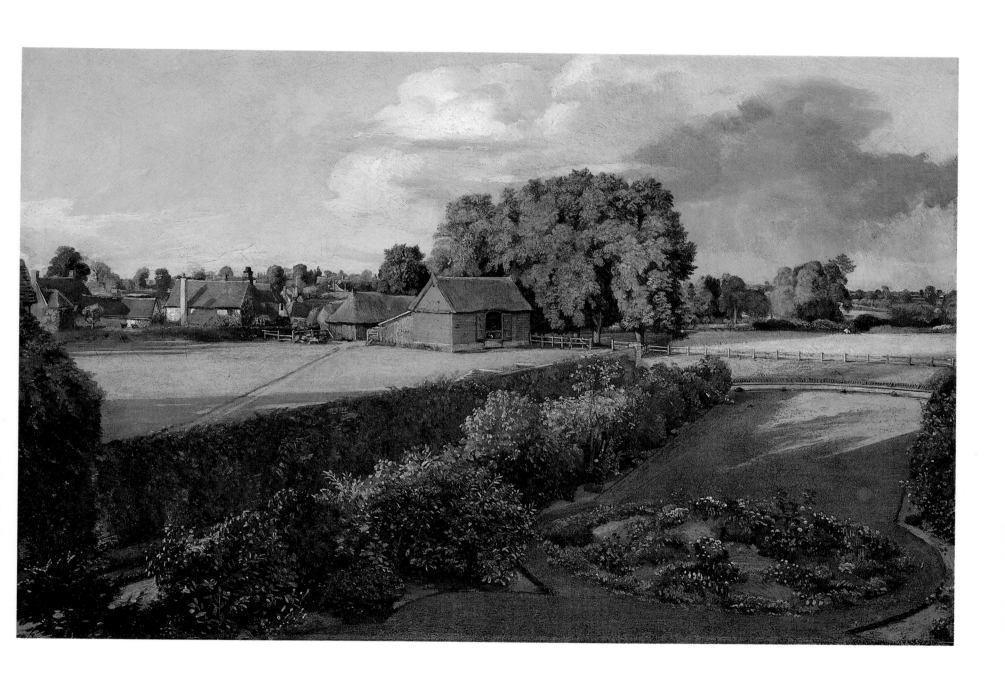

Golding Constable's Kitchen Garden, 1815

Oil on canvas, 33 × 50.8 cm. Ipswich, Museums and Galleries

Whilst the two paintings of his father's gardens and the lands beyond are concerned primarily to demonstrate the effects of good husbandry, the scenes they represent also had profound sentimental associations for Constable. He had fallen in love with Maria Bicknell in 1809, and although they did finally marry in 1816, the intervening years saw a difficult courtship largely due to the opposition of her grandfather, Dr Durand Rhudde, the rector of East Bergholt. It was in the rectory (located almost in the centre of this painting) that Maria often stayed during her visits to the village. Constable's letters to Maria help to explain why he painted and studied the view out towards her grandfather's home on at least six occasions after 1809. In 1814, he wrote: 'I can hardly tell you what I feel at the sight from the window where I am now writing of the feilds in which we have so often walked a beautifull calm Autumnal setting sun is glowing upon the gardens of the R[ector]y and adjacent feilds – where some of the happiest hours of my life were passed.'

Constable also described those fields as having witnessed 'the scenes of my boyish days', but late in 1815 those associations are likely to have been coloured by melancholy, for his mother had died in March and his father was becoming increasingly ill. After his father's death the house was sold and the family moved to Flatford in 1819.

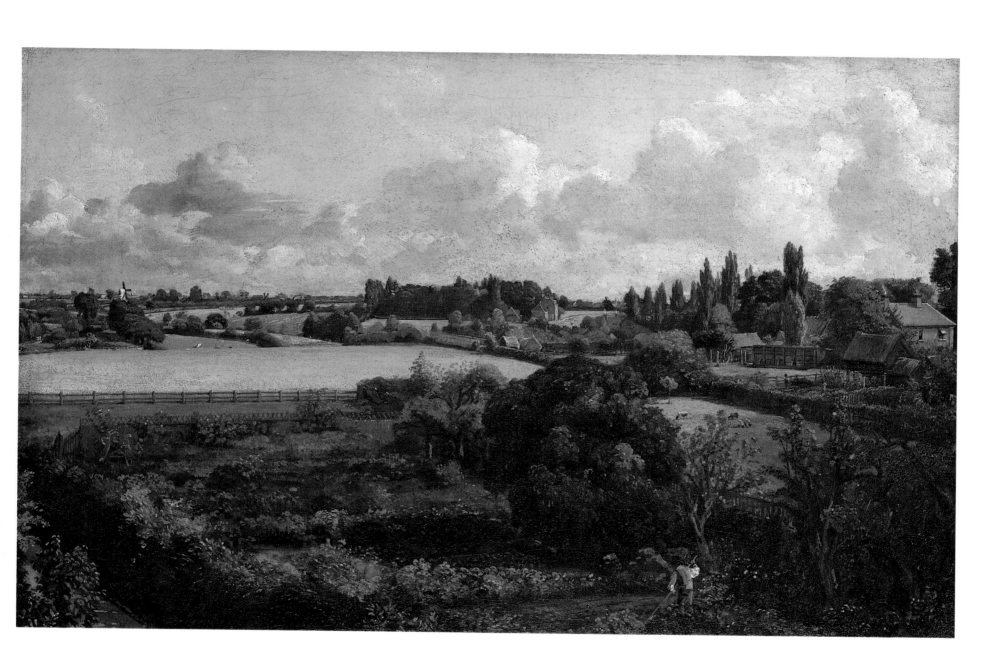

Wivenhoe Park, 1816

Oil on canvas, 56.1 × 101.2 cm. Widener Collection, National Gallery of Art, Washington, DC

Constable's view of *Wivenhoe Park* near Colchester is a country house portrait, a specialized department of landscape art with its own particular requirements. Such paintings, produced on commission, were frequently lucrative but they were not usually to Constable's liking: 'a gentleman's park', he declared in 1822, 'is my aversion'. Nonetheless he produced highly competent house portraits throughout his career: of *The Old Hall, East Bergholt* in 1801; views of Malvern Hall, Warwickshire, in 1809 and 1821; and of Englefield Hall, Berkshire, in 1833. But *Wivenhoe Park* was the most successful. It was painted for General Francis Slater-Rebow, whose daughter Mary is just visible driving a cart on the right of the picture. Whilst at work on the commission he was a house guest of the General, who, according to Constable, 'regretted my departure, and should always consider me a friend and be glad to see me'. Rebow's sympathetic patronage must partly account for the picture's success.

Manicured parklands in the style of Capability Brown were a far cry from Constable's normal agricultural landscape, but he has skilfully adapted a standard formula for the genre – a distant view of the house and grounds with an intervening stretch of water (as in his earlier *Malvern Hall*) – to place a great emphasis upon the sky, the weather and practical husbandry (such as the netting of fish and the grazing cattle), whilst the house itself is partly obscured by a clump of trees.

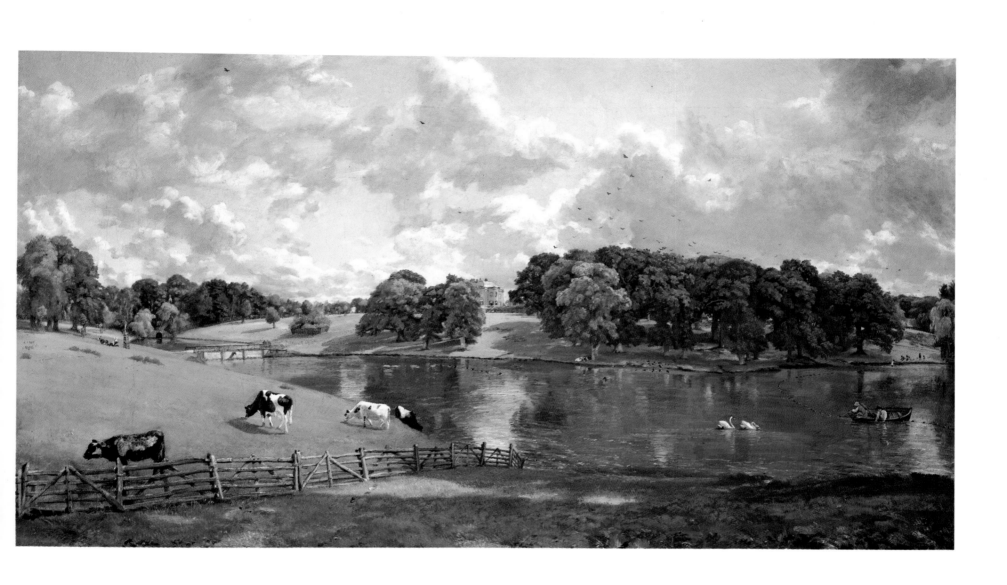

Weymouth Bay, c. 1816

Oil on canvas, 52.7 × 74.9 cm. National Gallery, London

Constable married Maria Bicknell at St Martin-in-the-Fields on 2 October 1816. John Fisher, who had officiated at the wedding, invited them to spend their honeymoon with him and his wife at their vicarage at Osmington in Dorset. Fisher tempted him with the prospect of views that were 'wonderfully wild & sublime & well worth a painter's visit'; he even promised to supply Constable with 'brushes, paints & canvass in abundance', and during the six weeks of their stay he was as good as his word. Constable produced numerous studies of Osmington and Weymouth Bays, some of which may have been painted out of doors. The National Gallery canvas seems large for *plein-air* work until it is remembered that both *Boatbuilding* and the *View of Dedham* are comparable in size; furthermore, some of the techniques employed, such as the 'shorthand' notation of the waves and clouds, do suggest that it was painted rapidly and thus perhaps before the motif. Throughout the picture Constable exploits the brown ground colour of the canvas with great ingenuity: it is visible through the sea, imparts a note of warmth to the sky, and above all, is left uncovered to represent the beach.

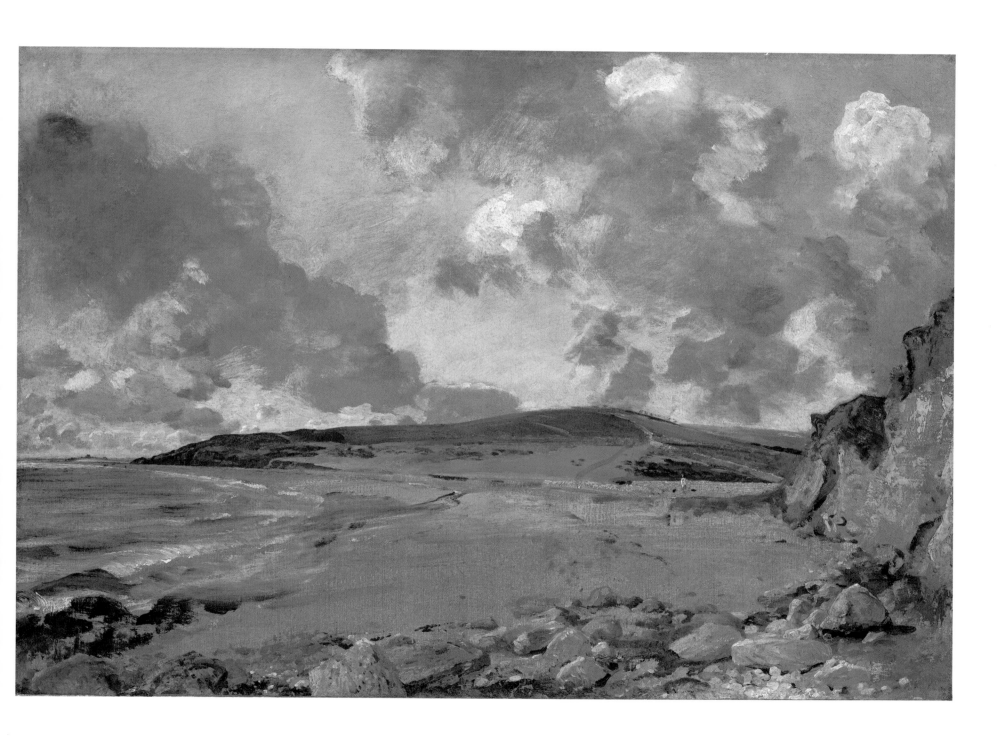

Flatford Mill, 1817

Oil on canvas, 101.7 × 127 cm. Tate Gallery, London

Constable exhibited this view of Flatford Mill with the title 'Scene on a navigable river' in 1817. In its detailed naturalism it recalls his earlier *Boatbuilding* (p. 73), but it is on a much larger scale and this would have made it difficult, though not impossible, to have painted the picture out of doors. His correspondence with Maria, whom he was about to marry, certainly does suggest that he needed constant recourse to nature and was reluctant to complete the painting away from Suffolk. In a thoughtless letter, dated 12 September 1816, he regretted that he would have to suspend work upon it because of their impending wedding.

It was well received at the exhibition and to this day remains one of his most popular and frequently reproduced paintings. The view, which looks towards the lock and mill buildings, is taken from the southern or Essex side of the River Stour, with the post of Flatford Old Bridge just visible in the bottom left-hand corner. Constable's original title was carefully chosen, for this stretch of the Stour carried the barges and their cargoes (including his family's corn) on to the estuary at Harwich. On the right he shows two barges, which had previously been towed by the horse in the foreground, being disconnected and 'poled' under the bridge.

X-rays reveal that even after the exhibition Constable continued to worry at the picture: he repainted the trees on the right, whilst the boy with the stick in the middle distance was originally shown apparently feeding a tow-horse; in the final version that horse has been moved much further back, although the 'ghost' of the original can still be seen beneath the overpainting.

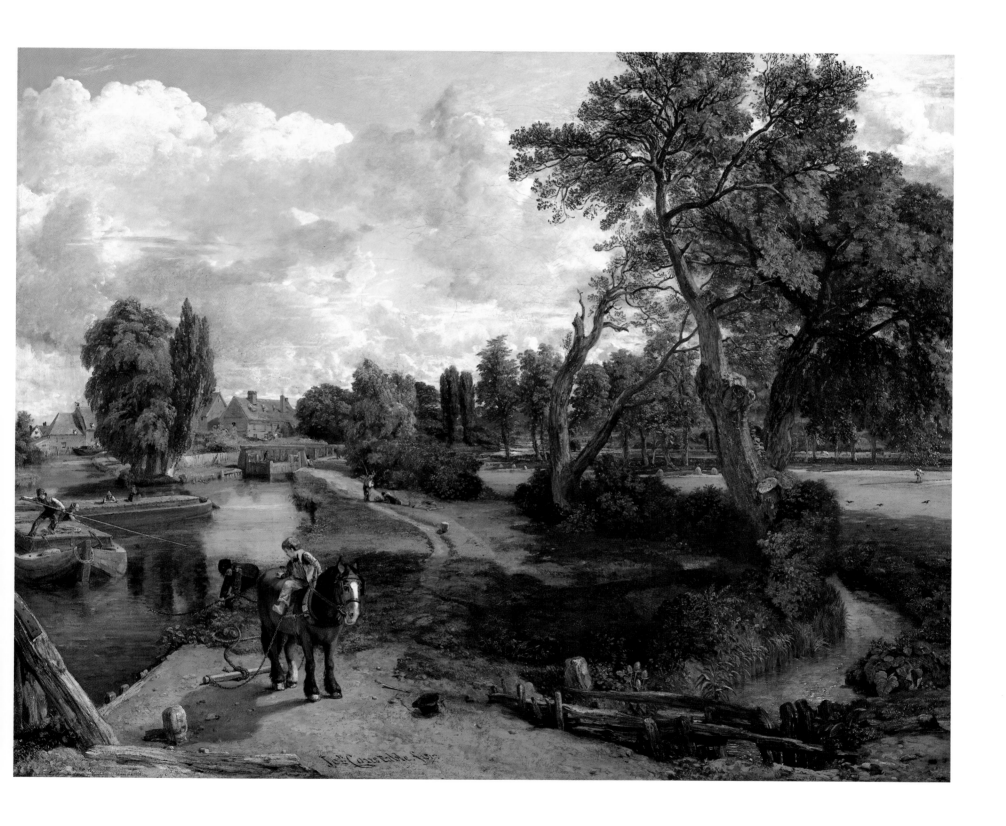

The White Horse, 1819

Oil on canvas, 131.5 × 187.8 cm. Frick Collection, New York

C. R. Leslie was right to claim that the *White Horse* was 'the most important picture to Constable he ever painted'. It was the first of his 'six-footers' – the large-scale, ambitious Stour Valley landscapes which he hoped would advance his professional reputation, and the only picture he sent to the Academy in 1819. For once his hopes were fulfilled, since the picture was enthusiastically received by both his colleagues and the critics. The *Literary Chronicle* wrote of his 'grasp of everything beautiful in rural scenery', whilst the *Examiner* thought he displayed 'a greater fidelity to nature than any of his more celebrated contemporaries'. Its success was instrumental in his election that year as an Associate of the Royal Academy. Constable later chose to send it to the British Institution's exhibition of modern masters in 1825, and to the Society of Fine Arts at Lille, where it received a gold medal.

In many respects *The White Horse* has much in common with *Flatford Mill* (p. 83) of 1817: both concentrate upon the commercial traffic of the river, describing the activities of the horse-drawn barges with the kind of documentary precision he had previously devoted to farming practices around East Bergholt. In the later picture the horse of the title (they were trained to step onto the barges) is being carried from one bank of the river to the other at a point just below Flatford Lock where the tow path changes sides. However, the larger scale of *The White Horse* entailed a change from the kind of working methods he employed on *Flatford Mill*. It was impractical to work on a six-foot canvas out of doors, and thus Constable painted the picture from sketches and drawings in his Keppel Street studio in London. Since constant reference to the motif was no longer imperative, the rhythm of his working year altered, allowing him to labour intensively upon the picture throughout the winter months.

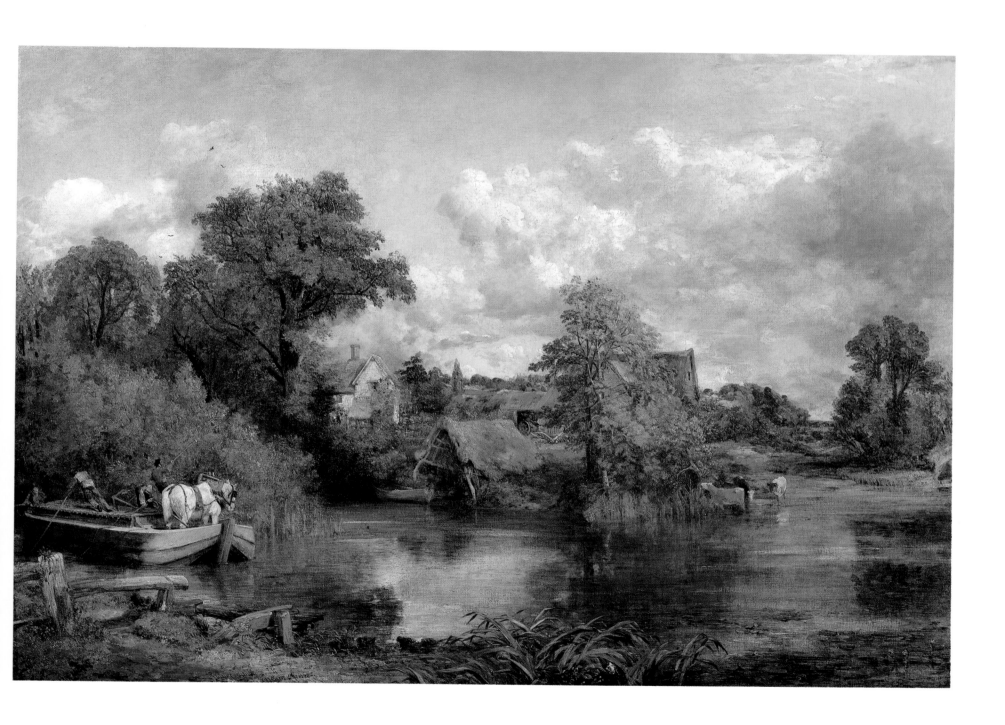

Branch Hill Pond, Hampstead, 1819

Oil on canvas, 25.4 × 30 cm. Victoria and Albert Museum, London

Constable rented Albion Cottage, Upper Heath, in the summer of 1819 and began to sketch the unfamiliar Hampstead terrain whose character provided such a strong contrast to his native Suffolk. Although he chose not to exhibit a Hampstead subject at the Royal Academy until 1821, he nonetheless painted many pictures of the Heath in the two intervening years. This study of Branch Hill Pond, which is inscribed 'End of Octr. 1819' on the stretcher, is thought to be Constable's earliest surviving Hampstead painting; the same view, looking south-west beyond Kilburn towards the Thames Valley, recurs in other pictures, most notably his Royal Academy exhibit of 1828, which reproduces the main features of this sketch very closely.

The 1819 picture is unusual in many respects: its composition, with the large sandbank to the right, appears deliberately awkward, and Constable modified it in other works by employing a higher viewpoint; the technique, involving thick impasto in parts and the liberal use of the palette knife, gives the work a richly textured surface. In choosing to depict the Heath under stormy conditions, Constable attempts to render something more than a topographical study.

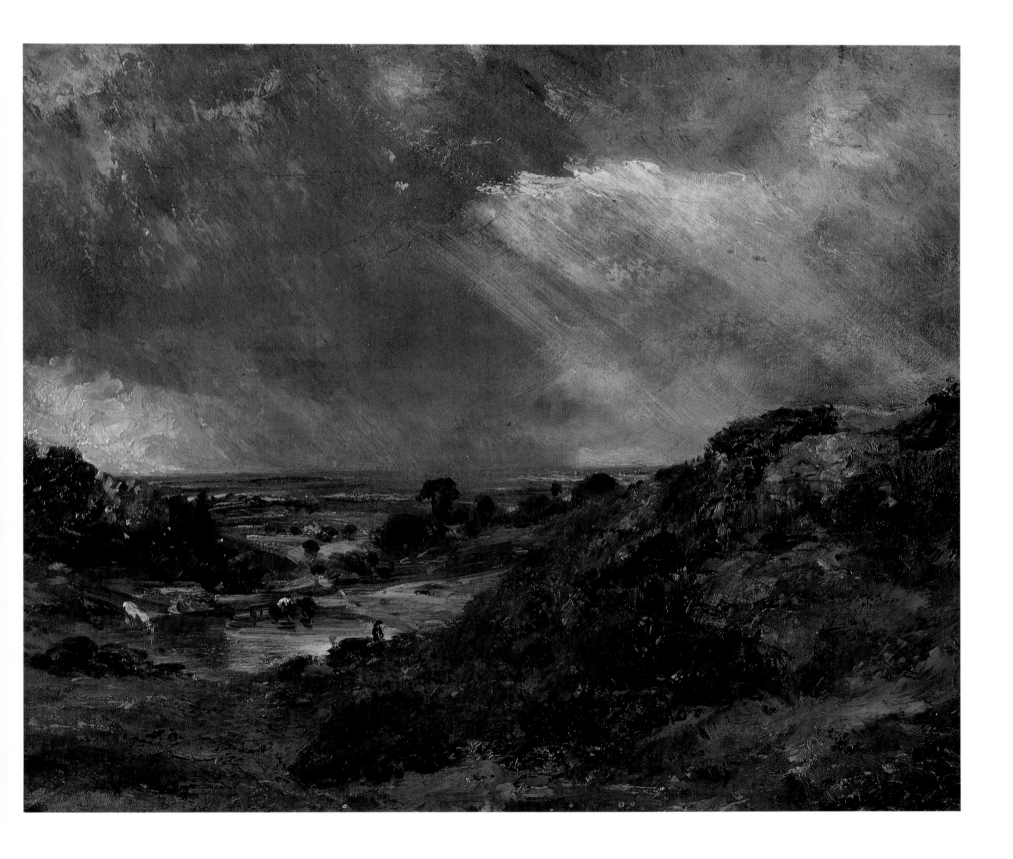

Hampstead Heath, c. 1820

Oil on canvas, 54 × 76.9 cm. Fitzwilliam Museum, Cambridge

This view of the Heath is probably one of the earliest finished pictures of a Hampstead subject that Constable made after moving his family there in 1819. The view, which looks out over the north and north-west towards Harrow church, is taken from near Whitestone Pond. A companion picture of almost identical proportions in the Victoria and Albert Museum looks in the other direction towards Highgate Hill. Together they exploit the elevated position to present an almost panoramic survey of the Heath and the surrounding countryside. The topography of the Heath may have suggested comparisons with certain Dutch landscapes of the seventeenth century, such as those of Philips Koninck, whose compositions frequently rely on a high viewpoint and broad expanse of scenery. In Constable's painting leisure and labour are shown together; figures strolling or idling in the background on the right are juxtaposed with the work depicted in the foreground. It is not clear precisely what Constable's labourers are doing; the economy of Hampstead was based upon the quarrying and excavating of sand and gravel, but in this case material is being emptied from the carts. It has been suggested that they are filling in hollows on the Heath to prevent them forming ponds after heavy rain.

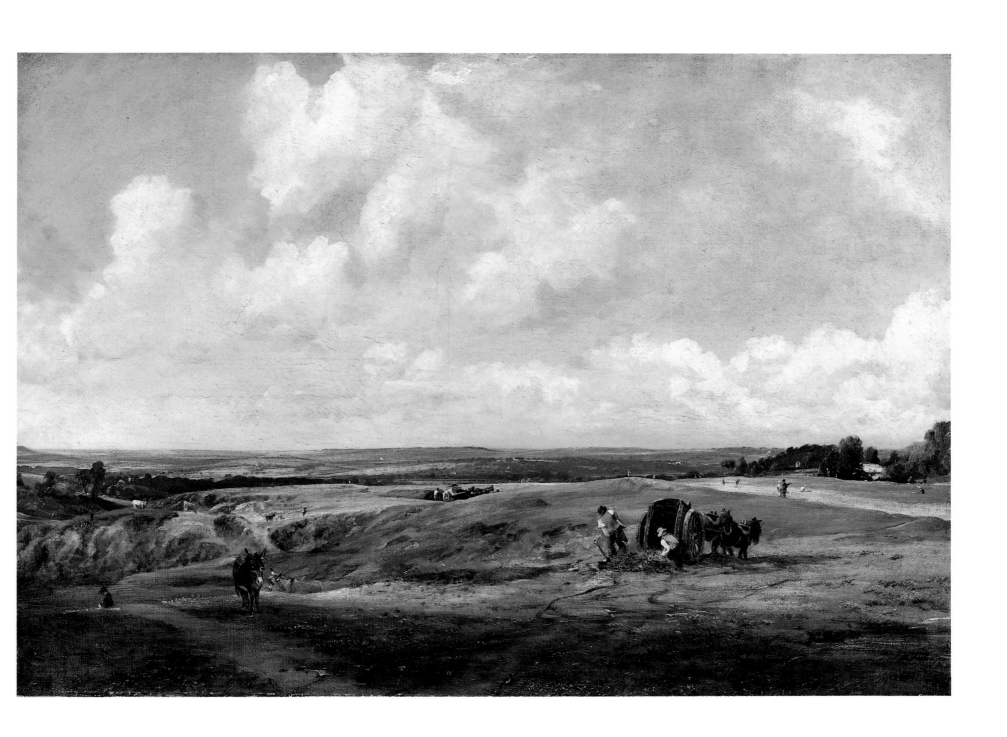

Harwich Light-House, c. 1820

Oil on canvas, 32.7 × 50.2 cm. Tate Gallery, London

Constable produced three almost identical paintings of Harwich Light-House, the wooden structure of which reminded him of a mill. He was well aware that sea pieces and coastal scenes were eminently saleable, particularly on the modest scale of the Tate Gallery picture. It is therefore no coincidence that he also made multiple versions of *Yarmouth Jetty*, a composition first shown in 1823 but one in which he cut corners by reusing the sky and cloud patterns from the earlier Harwich views. He later affected to dislike coastal views, complaining that their imagery was often hackneyed, but they were important to him in the early 1820s and he was unable to conceal his pleasure when he described their popularity in a letter to John Fisher, dated August 1823. 'Half an hour ago,' he wrote, 'I received a letter from Woodburne to purchase . . . one of my seapieces – but I am without one – they are much liked.' His family responsibilities forced Constable to maximize his income in the early 1820s, so he frequently duplicated his successful paintings, often with the help of Johnny Dunthorne (the son of his erstwhile friend in East Bergholt). Making replicas and variants for sale may sound strange to a modern ear, but it was a fairly common practice amongst Constable's contemporaries. One acquaintance of his, the history painter Benjamin Robert Haydon, was forced to make at least twenty-two versions of *Napoleon musing on St Helena* in order to avoid imprisonment for debt.

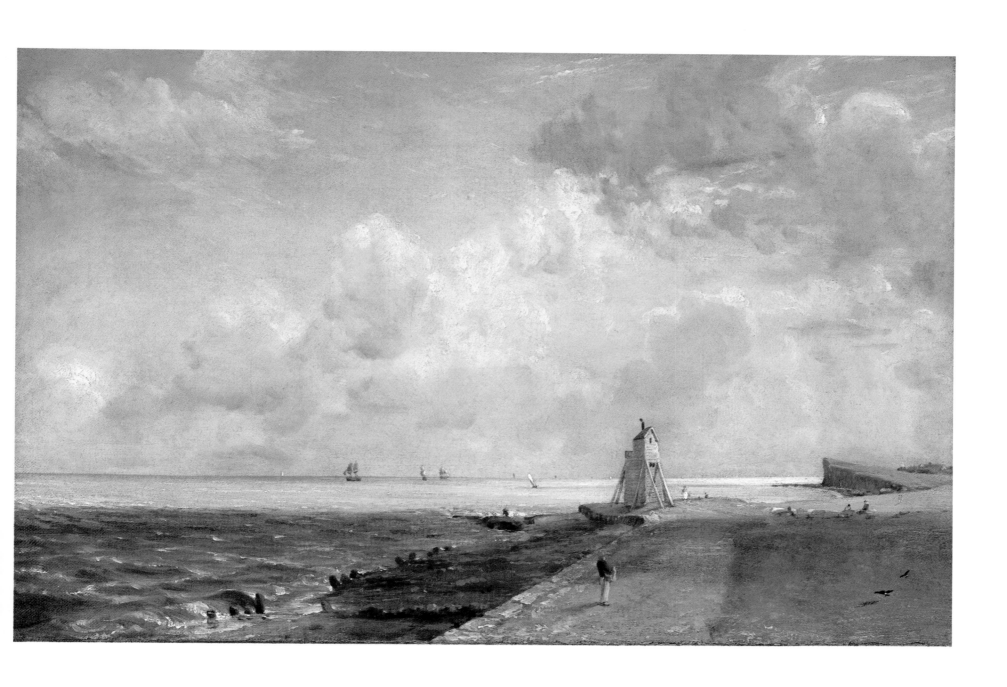

Landscape: Noon (The Hay-Wain), 1821

Oil on canvas, 130.5 × 185.5 cm. National Gallery, London

The *Hay-Wain* is the most celebrated and frequently reproduced of all British paintings, but like many very famous pictures it is now taken for granted and much misunderstood. To begin with, it must be seen not as unique but as part of the sequence of six-foot Stour Valley subjects that commenced with *The White Horse* (p. 85), to which, in the artist's words, it was 'a companion . . . in sentiment'; Joseph Farington, to whom Constable often turned for advice, even told him to suspend work on his *Waterloo Bridge* (p. 131) in order to finish the *Hay-Wain* and consolidate the success of his Suffolk views. The volume of praise given to the *White Horse* and *Stratford Mill* seems to have boosted Constable's self-confidence where large-scale studio pictures were concerned, for he brought the *Hay-Wain* to completion in a few months, against the expectations of his brother Abram, who wrote in late February 1821 that he hoped Constable would complete the painting in time for the exhibition, 'but from what I saw I have faint hopes of it, there appear'd everything to do'.

The familiarity of the subject-matter may also have increased his confidence, for he had sketched and painted the view towards Willy Lott's cottage many times in the past (p. 67) and he undoubtedly drew upon these earlier representations when planning and executing his grand six-foot picture. In one instance where he did not have a suitable drawing of 'a scrave or harvest waggon', he sent to East Bergholt and had one made for him by Johnny Dunthorne, the son of his former sketching companion. Dunthorne's sketch allowed Constable to sharpen the detail of the wagon in the finished picture, whereas in the six-foot sketch it had appeared undefined. In general, Constable made few changes to the composition of the full-size sketch, although he did paint out the horse and rider, then experimented with a barrel on the riverbank before overpainting that as well – both pentimenti are clearly visible in the finished picture.

The picture was well received but unsold at the Royal Academy and Constable let it go to the Parisian dealer, John Arrowsmith, who showed it with two other works at the Paris Salon. There it was greatly admired by Delacroix and Stendhal, and Constable was eventually awarded a Gold Medal by King Charles X, whose government offered to buy it for the nation. If Arrowsmith had not insisted on selling it as part of a package it would now hang in the Louvre rather than the National Gallery.

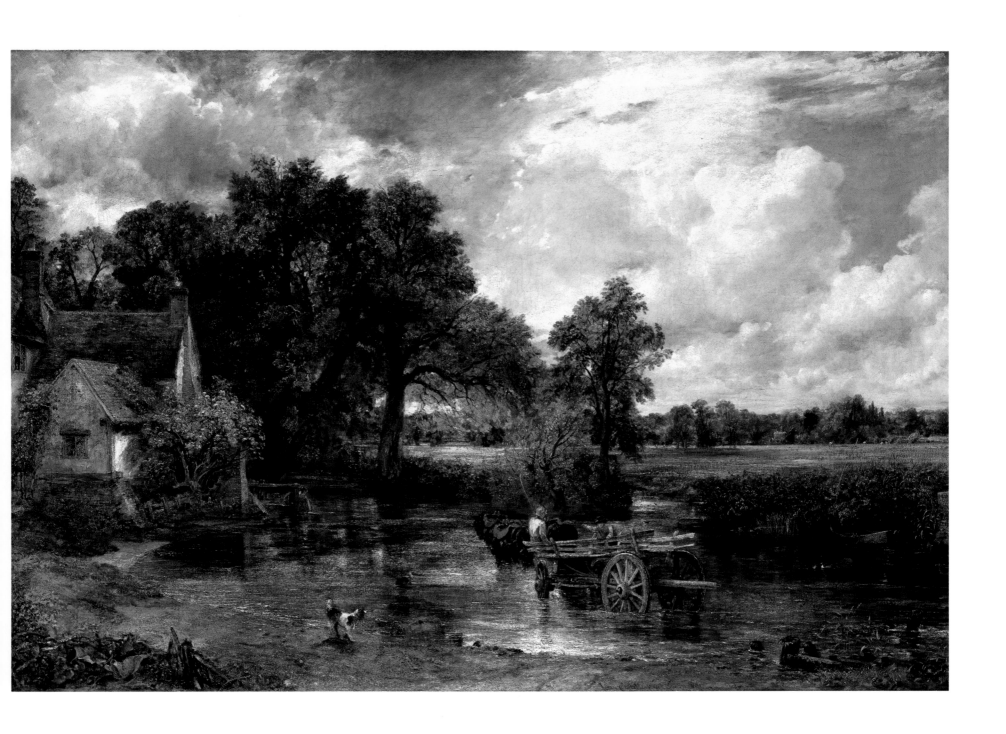

Cloud Study, 1821

Oil on paper on board, 24.7 × 30.2 cm. Paul Mellon Collection, Yale Center for British Art, New Haven

In a famous letter of 23 October 1821, Constable wrote to John Fisher to tell him that he had 'done a good deal of skying – I am determined to conquer all difficulties and that most arduous one among the rest.' Many artists painted sky and cloud studies in the early nineteenth century, but none more assiduously than Constable. He began his campaign of 'skying' on Hampstead Heath earlier in 1821, working in oils in spite of the formidable technical difficulties the medium presented when dealing with transitory cloud configurations. In his letter he explained to Fisher that the sky was of paramount importance to any landscape painter, for it was 'the "*key note*", the *standard of "Scale"*, and the chief "*Organ of Sentiment*". . . . The sky is the "*source of light*" in nature – and governs everything.'

In his concern for authenticity Constable would frequently label or inscribe his studies with details of the date, time and prevailing weather. In this case it was labelled: 'Sept'r 13th one o clock. Slight Wind at North West, which became tempestuous in the Afternoon, with Rain all the Night following.' These particulars have enabled researchers to date the painting accurately, for although Constable did not specify the year on his label, a meteorologist, Dr J. E. Thornes, has checked the sketches and inscriptions against contemporary weather records and found that this example must have been painted in 1821. Earlier sky studies included a fringe of treetops or land; Dr Thornes's research proves that this is the earliest surviving study to exclude them altogether.

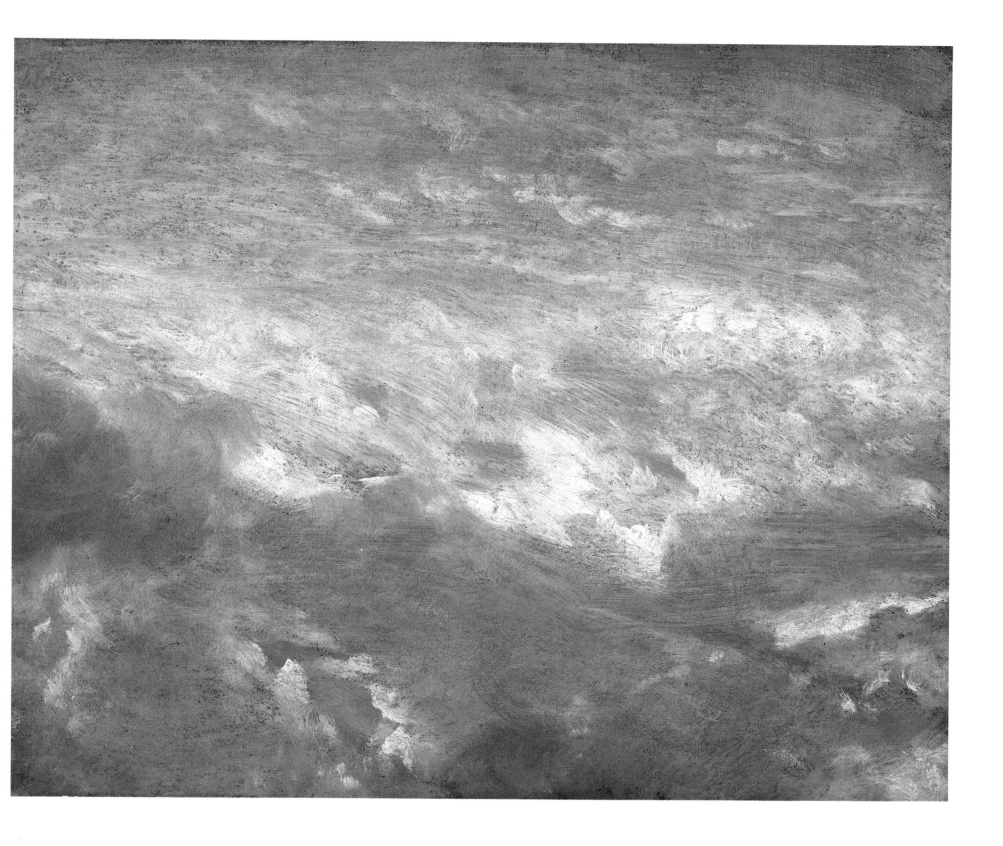

Study of Cirrus Clouds, 1822

Oil on paper, 11.4 × 17.8 cm. Victoria and Albert Museum, London

The remarkable accuracy of Constable's sky studies has been verified by checking the dated examples against contemporary meteorological records. This small oil sketch on paper is undated, but the word 'cirrus' has been written on the back, indicating that the artist was familiar with the classification of cloud forms first introduced by the London chemist Luke Howard in 1803. He seems to have encountered them in the second edition of Thomas Forster's *Researches about Atmospheric Phaenomena* (1815), a book which he both owned and annotated. His interest in skies, however, was long-standing and he did not use Forster's text uncritically; he put forward objections to it, based upon his own observations and the experience he had gained since working at his father's mill.

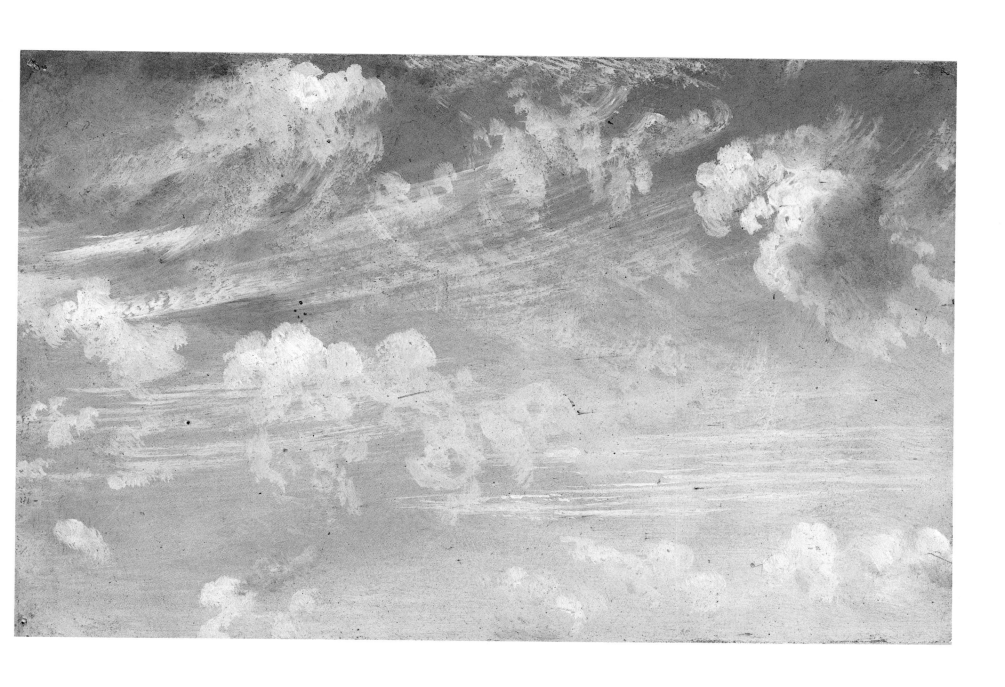

Landscape with Goatherd and Goats (copy after Claude), c. 1823

Oil on canvas, 53.3 × 44.5 cm. Art Gallery of New South Wales, Sydney

Copying from the Old Masters was an important part of an artist's education, and Constable continued to copy until well into his maturity. The paintings by Claude which belonged to Sir George Beaumont retained a special significance for him and he is known to have copied the *Goatherd with Goats* (p. 13) twice. This is the later of the two versions and was made during a six-week stay at Beaumont's Leicestershire country house in October and November 1823. In a letter to Maria, who was at home looking after the children, he claimed to 'have slept with one of the Claude's every night', and went on to justify his absence by explaining that he had 'a little Claude in hand a Grove scene of great beauty and I wish to make a nice copy of it to be useful to me as long as I live – It contains almost all that I wish to do in Landscape.' Maria was unimpressed with his excuses and replied, 'as to your Claude I would not advise you to show it to me for I shall follow Mr Biggs advice and throw them all out of the window'.

Constable believed, probably mistakenly, that Claude painted the picture before nature and this may be one reason why he valued it so highly, although in 1823 his own art depended heavily upon studio work. He also thought of his copy as an investment, since he wrote that 'by being really finished . . . [it] . . . will be worth something and a piece of property – it is so well.' His version is a little larger than the original and he was unable wholly to match Claude's tones (especially in the distance), but it is otherwise very faithful. On this occasion he is at odds with Sir Joshua Reynolds, who 'Consider[ed] general copying as a delusive kind of industry' and suggested rather that the artist should set up in competition with his model.

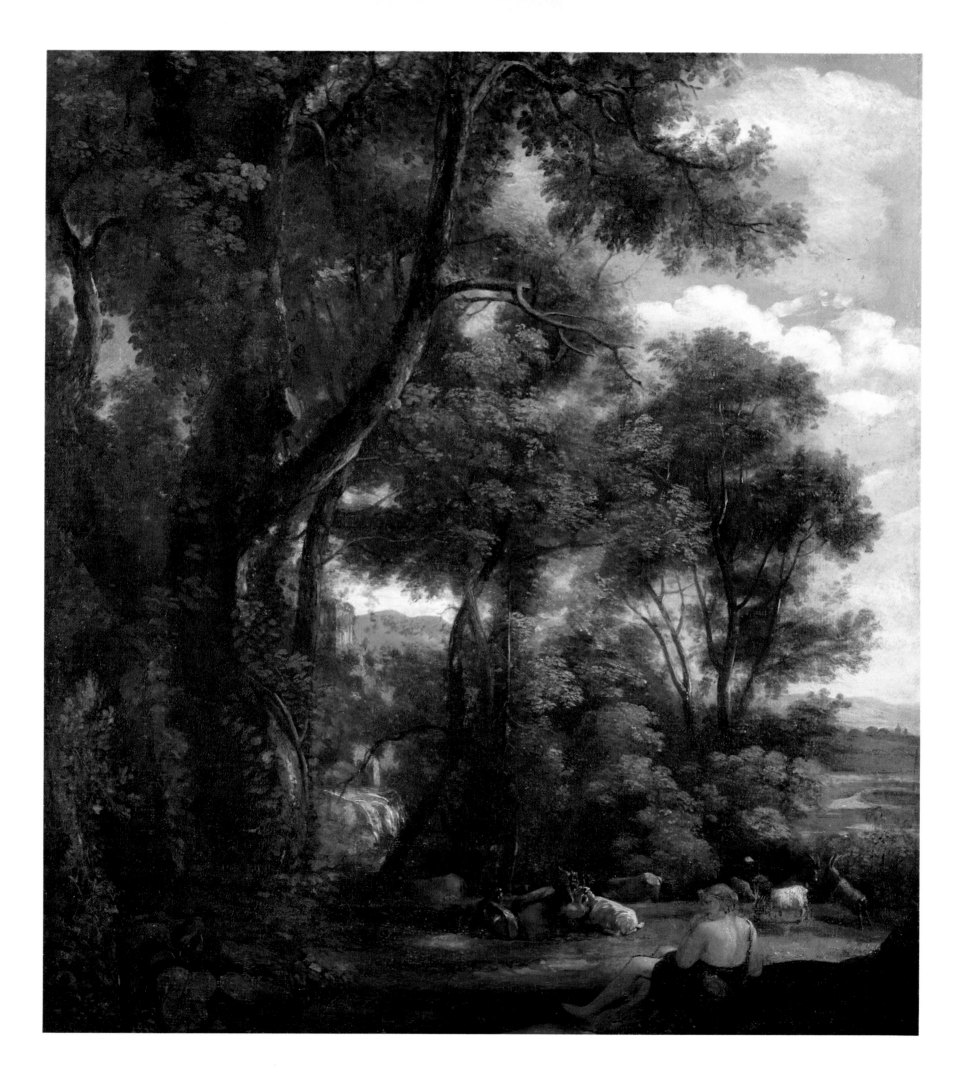

Salisbury Cathedral, from the Bishop's Grounds, 1823

Oil on canvas, 87.6 × 111.8 cm. Victoria and Albert Museum, London

In 1811 Constable was invited to stay at Salisbury, where he was introduced to the Bishop's nephew, the Revd John Fisher (who subsequently became Archdeacon of the cathedral). He and Constable enjoyed a lifelong friendship, and consequently Salisbury and its cathedral became one of the artist's most important subjects; this version, a south-west view, was commissioned by Fisher's uncle for his London house. The Bishop and his wife have been introduced on the left, where they are seen apparently admiring the church.

The commission gave Constable a great deal of trouble, for although he had sketched and drawn the cathedral before, he then had no patron to satisfy and could gloss over the kind of architectural detail that the Bishop would expect to see. He confided to John Fisher that 'It was the most difficult subject in landscape I ever had upon my easil. I have not flinched at the work, of the windows, buttresses, &c, &c, but I have as usual made my escape in the evanescence of the chiaroscuro.' Unfortunately, the Bishop was not as satisfied with the chiaroscuro as the artist was; he disliked the 'dark cloud' in the painting, saying, according to his nephew, '[If] Constable would but leave out his black clouds! Clouds are only black when it is going to rain. In fine weather the sky is blue.' At first Constable agreed to repaint it but preferred in the end to paint another, more acceptable version with the aid of Johnny Dunthorne.

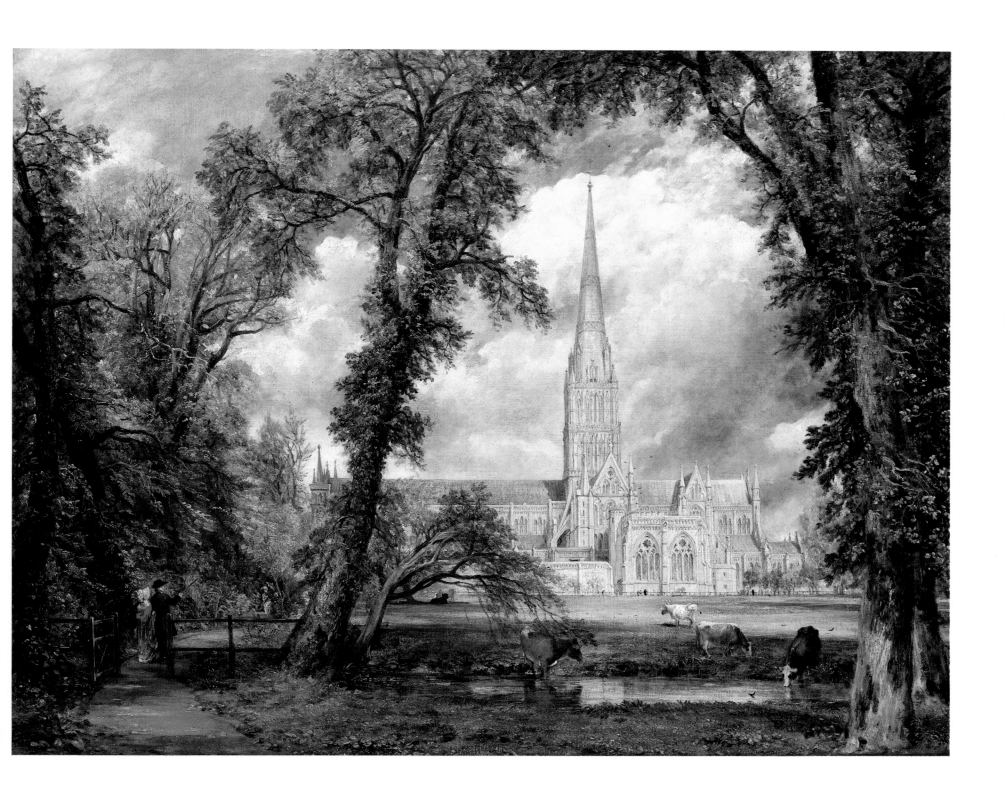

The Lock (A Boat Passing a Lock), 1824

Oil on canvas, 142.2 × 120.7 cm. Walter Morrison Collection, Sudeley Castle

Unlike the other large Stour Valley scenes, *The Lock* is not a six-foot canvas and is the only one in the series in an upright format. Constable hoped originally to exhibit the picture in 1823 but was prevented from doing so by his work on the *Salisbury Cathedral* (p. 101). He seems to have been anxious about *The Lock*, but unnecessarily so, for when it was finally exhibited in 1824 it received a good press and he sold it on the first day for 150 guineas to James Morrison, a successful draper. The subject is Flatford Lock, which he had painted many times, but seen at close quarters and from a low viewpoint, giving an original and distinctive composition. The painting focuses upon the action of the lock-keeper, who uses a crowbar to turn the roller which opens the sluices, thereby lowering the water level in the lock and allowing the barge downstream towards the estuary.

The imagery is consistent with his earlier Stour scenes, but as Constable acknowledged, the handling and treatment are different. He called it 'an admirable instance of the picturesque', a description which would not easily fit the bulk of his previous work, although his execution, he noted, 'annoys most of them [presumably his colleagues] and all the scholastic ones'. Constable's handling came in for increasing criticism after 1824, but the reviewer for the *Literary Gazette* thought it was highly appropriate in *The Lock*, where the broken touches and traces of the palette knife conveyed 'the qualities of roughness and of sudden variation' which the theorist Uvedale Price believed were essential to the picturesque.

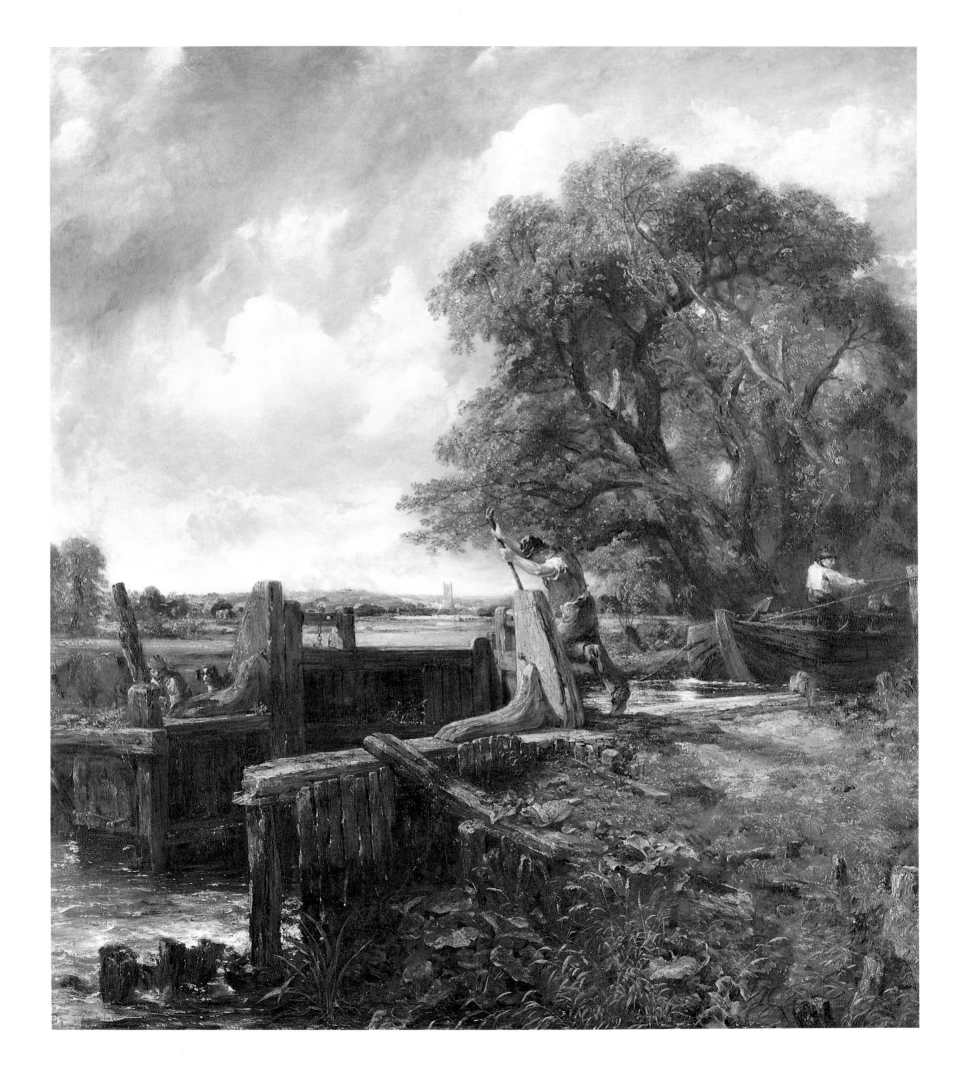

Brighton Beach with Colliers, 1824

Oil on paper, 14.9 × 24.8 cm. Victoria and Albert Museum, London

On 5 January 1825, Constable lent John Fisher a dozen oil sketches of Brighton that he had made the previous year, of which this is one of the finest. He took his family to Brighton for the sake of his wife's health in May 1824, and although he was forced to return intermittently to London, he managed to spend three uninterrupted months with them from July to October. The oil sketches seem to have been painted before nature, for Constable described how they were 'done in the lid of my box on my knees as usual,' and this may account for their freshness and vigour. He supplemented his pictorial observations with a remarkable inscription on the back – a combination of colour notes and diary entry: '3d tide receding left the beach wet – Head of the Chain Pier Beach Brighton July 19 Evg., My dear Maria's Birthday Your Goddaughter – Very lovely Evening – looking Eastward – cliffs & light off a dark [? grey] effect – background – very white and golden light.'

The inscription demonstrates the extent to which Constable's Brighton subjects and family life were inseparable to him, but since it was clearly addressed to Fisher (he was Maria Louisa's godfather) it also raises the question as to whether the sketch was made with him in mind, or, alternatively, the notes added at a later date.

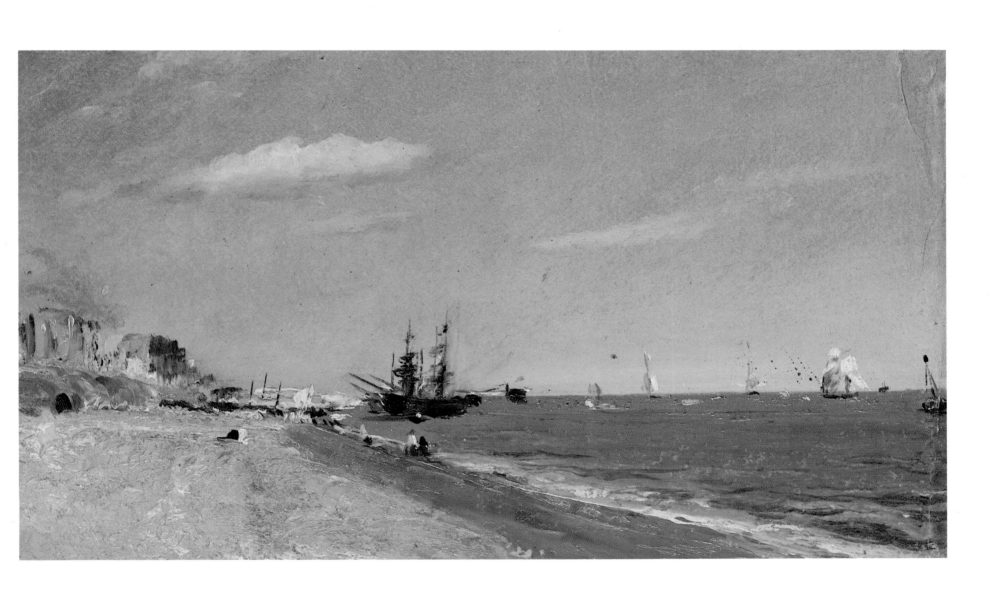

Full-Size Sketch for 'The Leaping Horse', 1824–1825

Oil on canvas, 129.4 × 188 cm. Victoria and Albert Museum, London

Constable adopted the full-size sketch as an important part of his practice when he began work on the series of six-foot Stour Valley pictures. When Constable had confined himself to more modest canvasses, the disparity between the size of his sketches and the finished painting was of less importance, but for his newly ambitious studio pieces he apparently needed to try out the effectiveness of his ideas on the scale upon which they would finally be seen. In the case of *The Leaping Horse* there are considerable differences between the sketch and the finished picture (p. 109): the exhibited work has one barge rather than two, the willow stump was shifted to the left, and a cow, clearly visible in the sketch, has been painted out.

Leslie accounted for some of these disparities by suggesting that Constable was actually trying out two solutions simultaneously, and finally decided to work up the Royal Academy's picture (p. 109) for exhibition. According to him, 'So carefully did he study this subject, that he made, in the first place, two large sketches, each on a six foot canvass. One was, I believe, intended to be the picture, but was afterwards turned into a sketch.' Leslie left this observation out of the second edition of his biography, possibly because he then thought it inaccurate, but some differences corresponding to those between the sketch and the finished picture also occur in two drawings in the British Museum, which may represent alternative proposals for the subject. Leslie's first thoughts could therefore have been correct.

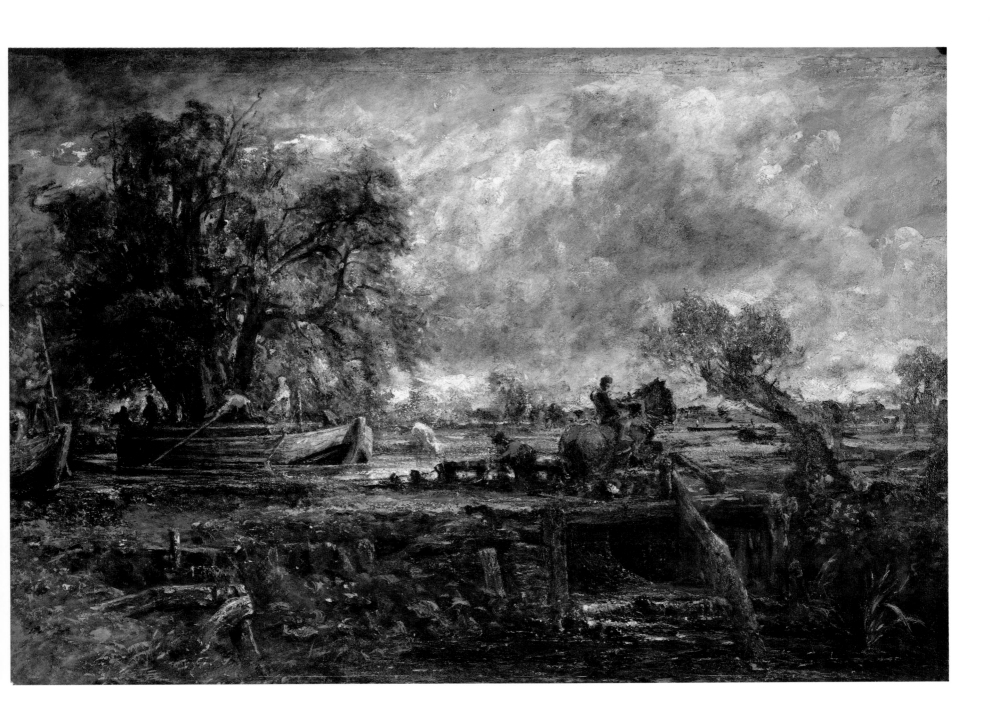

The Leaping Horse, 1824–1825

Oil on canvas, 142.2 × 187.3 cm. Royal Academy of Arts, London

On 8 April 1825, Constable told John Fisher about *The Leaping Horse*, his major exhibition piece of that year: 'I have worked very hard,' he wrote, 'but I must say that no one picture ever departed from my easil with more anxiety on my part with it. It is a lovely subject, of the canal kind, lively – & soothing – calm and exhilarating, fresh – & blowing, but it should have been on my easil a few weeks longer.' In spite of his nervousness and its unfinished condition the painting was well received by the critics, although it failed to find a purchaser, and Constable continued to work on it after the exhibition in an attempt to make it more saleable. He moved the willow stump from the right to the left of the horse (traces of the original tree are just visible beneath the overpainting) and probably added the white accent of the sail to balance the overall composition.

Unlike his other Stour Valley paintings, the location of *The Leaping Horse* is far from certain. It has been suggested that Constable's viewpoint was at the sluice where the old channel of the Stour leaves the navigable river, and that since the old channel marks the Essex–Suffolk border, the horse is leaping from one county into the other. From that point, however, the tower of Dedham church would have been behind the artist and not in his line of sight. It appears, therefore, that topographical precision was not his primary consideration: even when he described the subject to Francis Darby, a potential buyer, it was in general terms as a 'Scene in Suffolk, banks of a navigable river, barge horse leaping on an old bridge' – the tower of Dedham church is the only detail he mentioned by name. Constable may have reshaped the terrain but according to C. R. Leslie the incident he records was an authentic local custom. The towpaths of the Stour were interrupted by obstacles intended to prevent cattle from straying, but since these had no gates it was necessary to teach the tow-horses to leap over them.

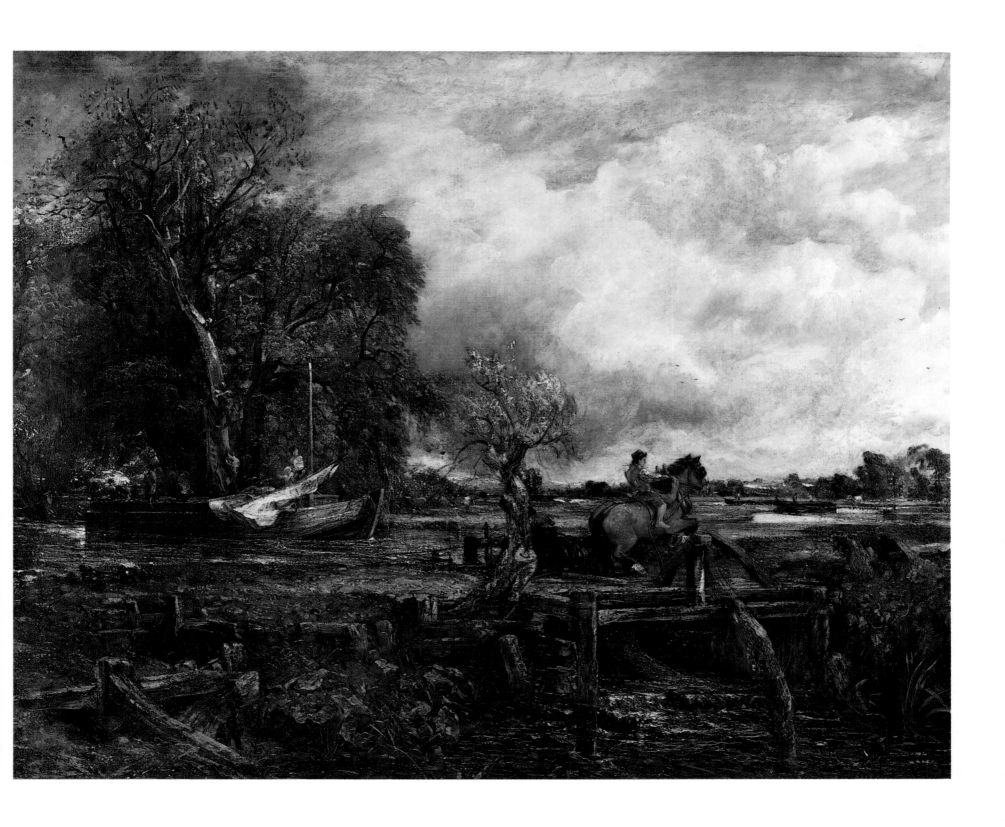

A Mill at Gillingham in Dorset (Parham's Mill), 1826

Oil on canvas, 50.2 × 60.3 cm. Yale Center for British Art, New Haven

Although Gillingham Mill is not one of Constable's most famous subjects, he depicted it many times and seems to have held it in great affection. On his second visit to Gillingham in 1823, when he wrote that 'the mills are pretty. and one of them wonderfull old & romantic', it is clearly Parham's (or Perne's) Mill to which he refers. His friend John Fisher held an ecclesiastical living at Gillingham and it was he who first drew Constable's attention to the mill's potential as a motif; he later commissioned a small oil from Constable (now in the Fitzwilliam Museum, Cambridge) based upon the artist's initial oil studies.

This larger version of the subject was painted for a Mrs Hand, who first approached Constable with the commission in 1824. For her benefit he elaborated upon the scene he had painted for Fisher by adding the donkeys and ducks. He referred to it as 'one of my best pictures', which is perhaps a little surprising, for although it is as 'rich and pleasing' as he claimed it is also highly conventional both in its subject-matter and composition.

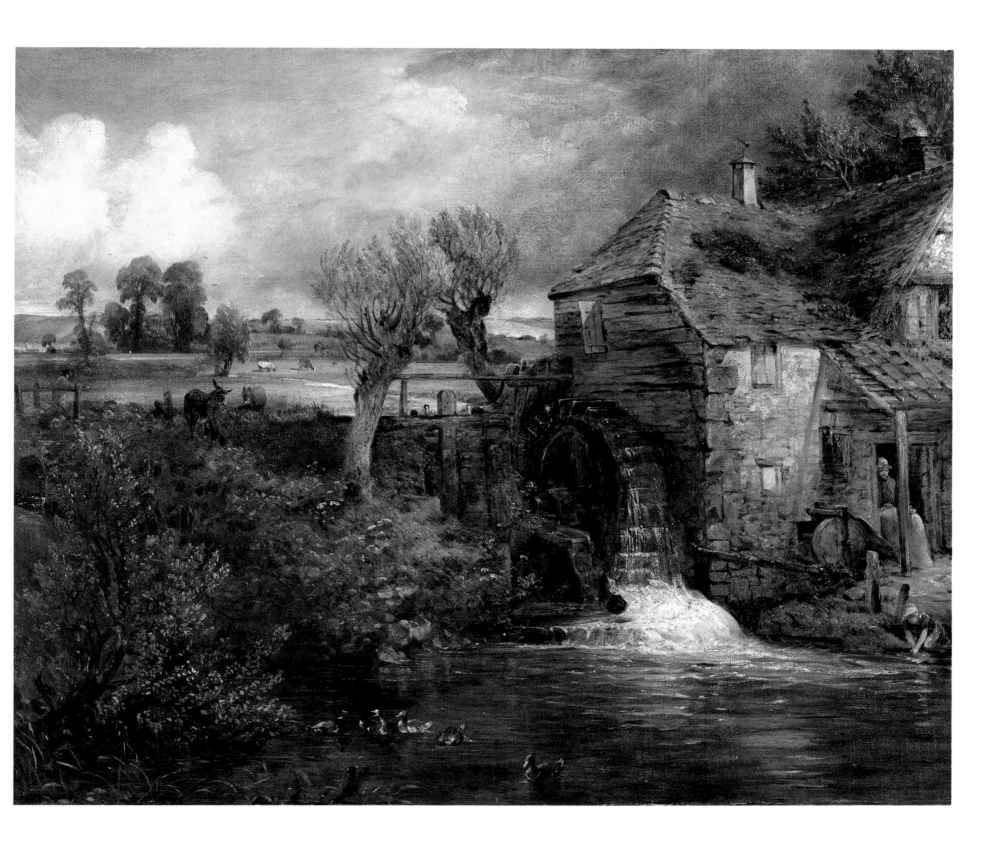

The Cornfield, 1826

Oil on canvas, 143 × 122 cm. National Gallery, London

The Cornfield was the first painting by Constable to enter a national collection. After the painter's death his friend William Purton suggested to C. R. Leslie that 'one of his works should be purchased by a subscription among the admirers of his genius, and presented to the National Gallery'. Purton's choice would have been *Salisbury Cathedral, from the Meadows* (p. 127) but the majority of subscribers vetoed it and selected *The Cornfield* instead. Their reasons are given by one of their number, the miniaturist Andrew Robertson, who described it as having 'all his truth of conception, with less of the manner that was objected to' in works like the *Salisbury Cathedral*. Many objections were lodged against the handling of Constable's later pictures, but as Robertson noted, *The Cornfield* is a conspicuous exception, for the artist set out to make it as seductive and marketable as he could. He told Fisher 'it has certainly got a little more eye-salve than I usually condescend to give to them.'

His 'eye-salve' takes several forms: the painting is carefully studied and finished – 'not neglected in any part' was how he described it to Fisher. In addition Constable has introduced far more anecdotal and incidental detail than he would normally have done: the donkey and foal, the dog, the sheep, the broken gate and the drinking boy are all intended to capture the viewer's interest. Finally, he went out of his way to make the picture botanically accurate: one of his friends, Henry Phillips of Brighton, was a botanist and he advised Constable which species of plants would be in flower around such a lane in July; at least three of those he mentions – cow parsley, bramble and water plantain – were included in the picture. The scene was identified by Charles Golding Constable, the painter's son, as Fen Lane, the route leading from East Bergholt to Dedham. Constable would have taken this track as a boy on his way to Dedham Grammar School. He has taken some liberties with the topography since the village of Higham seen in the far distance, marked out by its church tower, is not actually visible from that spot.

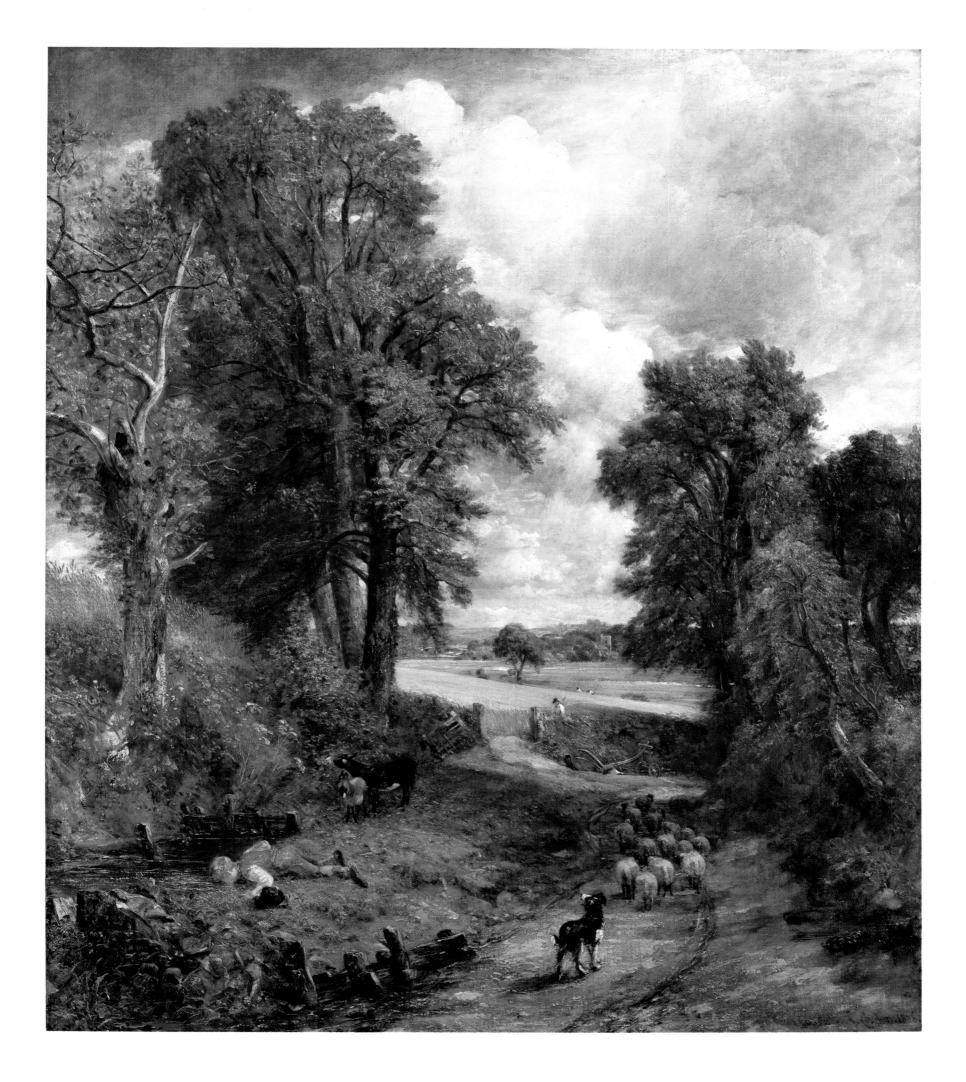

The Chain Pier, Brighton, 1827

Oil on canvas, 127 × 183 cm. Tate Gallery, London

The Chain Pier, which was shown at the Royal Academy in 1827, is the largest and most important work to have emerged from Constable's frequent visits to Brighton during his wife's convalescence. John Fisher, who had suggested to Constable that he needed to extend his repertoire of subjects, praised the picture, but in spite of what Constable described as 'a few nibbles' it found no purchaser. Even the publication of Frederick Smith's engraving in 1829 did nothing to encourage a sale. It may have been admired 'on the walls', as Constable claimed, but at least one newspaper found its colouring 'defective' and it seems overall to have had a mixed reception. This must have been both surprising and galling to Constable, whose previous marines had sold well (p. 91), leading him perhaps to believe that a large sea piece, on the scale of the Stour Valley scenes, would considerably enhance his reputation. This was probably a miscalculation, since larger works were more expensive and correspondingly less likely to sell.

A greater impediment still to the picture's popularity was what Fisher termed its 'ferocious beauties' – the turbulent sea and threatening sky. Constable was worried that the kind of material included in his Brighton picture would appear hackneyed, and he may have felt that by depicting inclement weather he would avoid any such banality. In December 1828 Fisher advised him to 'let in sunshine & serenity. It will be then the best sea-painting of the day.' To Constable, who had lost his wife the previous month, Brighton would always be associated with her failing health, and 'sunshine & serenity' had never been further from his mind.

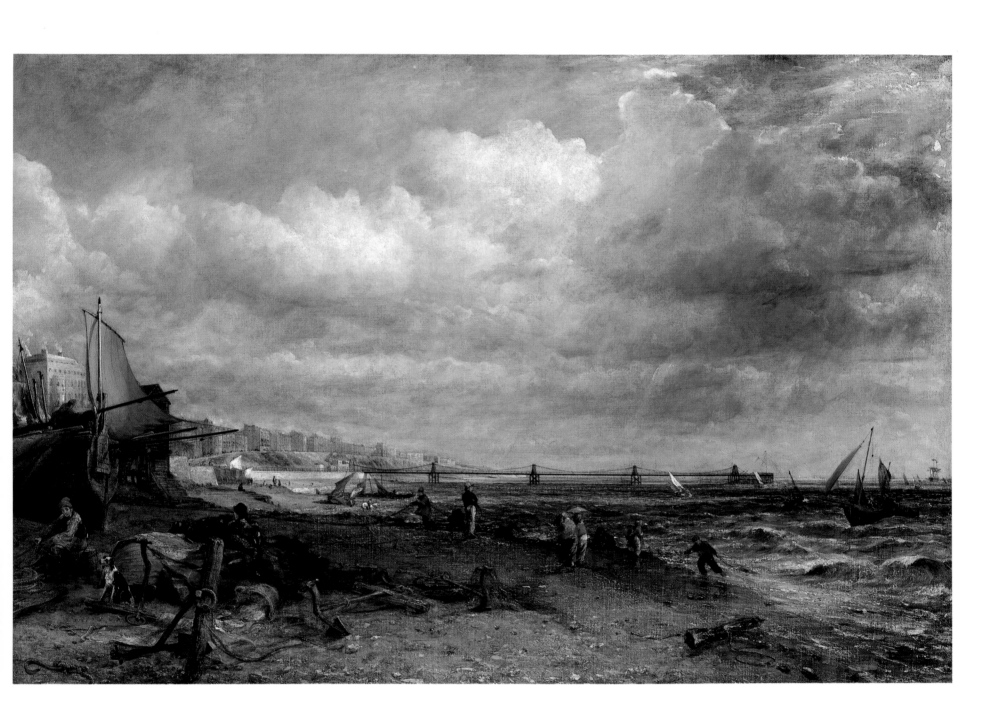

Dedham Vale, 1828

Oil on canvas, 145.2 × 121.9 cm. National Galleries of Scotland, Edinburgh

In this large exhibited oil Constable repeats the composition he first employed in his *plein-air* study of Dedham Vale twenty-six years earlier (p. 47). Like its predecessor it is based upon the Claude *Hagar* (p. 12) owned by Sir George Beaumont. Beaumont, however, had died the previous year, bequeathing his Claudes to the National Gallery, and it has been plausibly suggested that *Dedham Vale*, like *The Cenotaph* of 1836 (p. 137), was intended as a homage to Constable's friend and mentor. In its handling and treatment it resembles neither the *Hagar* nor the 1802 oil study: paint is freely applied using both the brush and palette knife, leaving a dramatically uneven surface and rendering some of the foreground detail difficult to read. But the most puzzling feature of the painting is the inclusion of the destitute mother and child huddling around a cauldron beside their makeshift shelter. They are sometimes interpreted as a picturesque detail included to help the work sell, and occasionally as a reference to the gypsy scenes of Gainsborough (whom Constable had admired since his youth). They are, however, treated in such a way as to introduce a note of harshness into the landscape that is far removed from much of his earlier work and not easily reconciled with contemporary notions of the picturesque.

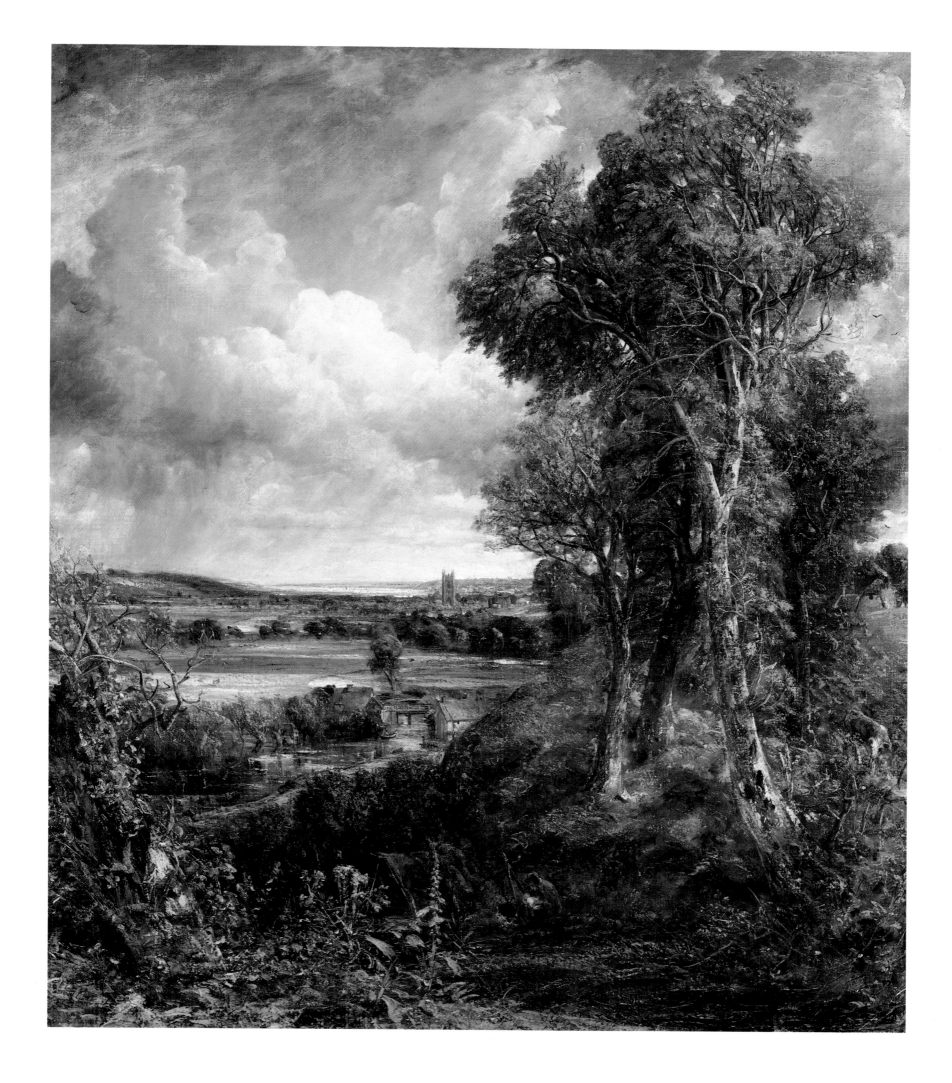

Full-Size Sketch for 'Hadleigh Castle', c. 1828–1829

Oil on canvas, 122.5 × 167.5 cm. Tate Gallery, London

Constable made his only visit to Hadleigh Castle in June 1814, when he was staying with a family friend, the Revd W. W. Driffield. A letter to Maria records his impressions: 'While Mr. D. was engaged at his parish I walked upon the beach at South End. I was always delighted with the melancholy grandeur of a sea shore. At Hadleigh there is a ruin of a castle which from its situation is a really fine place – it commands a view of the Kent Hills, the Nore and North Foreland & looking many miles to sea.' He made a small pencil sketch on that occasion which served, fifteen years or so later, as the basis for the oil painting now in the Yale Center for British Art.

That picture, which was exhibited at the Royal Academy in 1829, must surely be counted among the most dramatic of his large-scale compositions. The wildness of the landscape, together with the turbulence of the sky (more marked in the sketch) are often taken to be an expression of his state of mind after his wife's death in November 1828. He told Leslie the following January that if he could 'get a float on a canvas of six feet I might have a chance of being carried away from myself'. In fact he seems to have begun the picture before Maria died, and may have resumed work on it in 1829, when the desolation of the scene was consistent with his mood. The Tate Gallery version (the last full-size sketch Constable is known to have made) is an impasted exercise in chiaroscuro – far more vigorous than the finished picture. When they were auctioned at the Constable sale in 1838 the finished picture fetched £105 – the sketch made only £3. 13s. 6d.

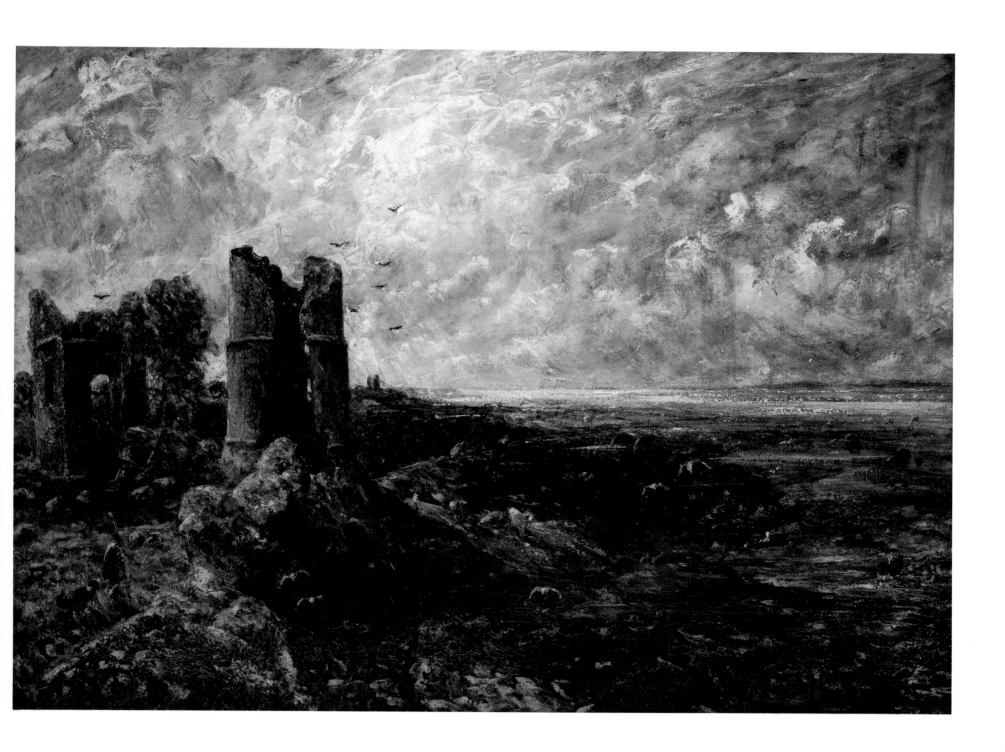

Old Sarum, 1829

Oil on card, 14.3 × 21 cm. Victoria and Albert Museum, London

In July 1829, during a holiday with the Fishers at Salisbury, Constable made two drawings of Old Sarum, one of which, a view from the south, was used as the basis for this small oil sketch. The sketch, however, with its cold colours and thundery, windswept effects, is far grimmer than either of Constable's drawings. It bears comparison with the grand Academy painting of *Hadleigh Castle* (p. 119) which he showed in the same year, and like that work it may partly express his desolation at the loss of his wife. After he returned from Salisbury, Constable began working with the engraver David Lucas upon the series of mezzotints known as *English Landscape*. Lucas's engraving after *Old Sarum* was accompanied by Constable's own text in which he stressed its melancholy decline from a once illustrious past.

The present appearance of Old Sarum – wild, desolate, and dreary – contrasts strongly with its former greatness. This proud and 'towered' city, once giving laws to the whole realm – for it was here our earliest parliaments on record were convened – can now be traced but by vast embankments and ditches, tracked only by sheepwalks.

Constable sent a proof of the engraving to the Academy's president, Sir Thomas Lawrence, who replied with a note thanking him and adding, 'I suppose you mean to dedicate it to the House of Commons?' Lawrence seems to have been referring, jokingly, to the fact that Old Sarum was one of the most notorious 'rotten boroughs' in the country, returning two members to Parliament even though it only had a population of seven. It was disenfranchised in 1832 under the terms of the Reform Act.

Landscape: A Study (Water-Meadows near Salisbury), 1829

Oil on canvas, 45.7 × 55.3 cm. Victoria and Albert Museum, London

This small but exquisite painting was begun during or soon after Constable's last visits to Salisbury in 1829. Malcolm Cormack has suggested that it may have been painted in the open air from behind John Fisher's house. Its descriptive precision and disciplined technique is reminiscent to some extent of his earlier *Boatbuilding* (p. 73), also painted before nature. It is therefore untypical of Constable's later Academy paintings, which helps to explain why it was 'accidentally' rejected by his colleagues from the 1830 exhibition. Members of the Royal Academy had an automatic right to exhibit, but outsiders had to submit their paintings to a Council of Academicians who would then admit or refuse them. Constable finally became a full member of the Royal Academy in 1829 and served on its selection Council the following year.

Under mysterious circumstances, his small landscape appeared before that Council and was promptly rejected by the other members before Constable acknowledged his authorship. The episode may have been an accident, a practical joke directed at the artist, or, it has been suggested, engineered by Constable himself. The latter is by no means as implausible as it sounds: he undoubtedly felt insecure about his status, particularly since the President, Sir Thomas Lawrence, told him bluntly that he was fortunate to have been elected a full Academician; under these circumstances he may have wished to put his colleagues' opinion of him to the test. It is worth pointing out that in all three accounts of the episode Constable remains silent until after the painting was condemned.

The Glebe Farm, c. 1830

Oil on canvas, 65.1 × 95.6 cm. Tate Gallery, London

Constable referred to this as 'one of the pictures on which I rest my little pretensions to futurity'. It is based upon an oil sketch of *A Cottage and Lane at Langham* which he painted around 1810, but the sketch did not include Langham church, which cannot actually be seen from the viewpoint Constable adopted in this picture. He had a good reason for taking liberties with the scene, for as he explained to John Fisher, the work was intended partly to commemorate Fisher's uncle, the Bishop of Salisbury, who had died in 1825. Bishop Fisher had taken a kindly interest in Constable's career, and although he could be an awkward patron the artist continued to hold him in high esteem. Langham church was, in Constable's words 'the poor bishops first living,' – he had been Rector of Langham when Constable was first introduced to him in 1798.

Many versions of the composition are known, but a number are posthumous copies by Constable's imitators. The Tate Gallery has two of the authentic versions: this one was given to C. R. Leslie as a present and its slight handling is directly attributable to his intervention. Constable was becoming notorious for labouring and reworking his surfaces, but Leslie, who saw him at work on the painting 'told him he liked it so much he did not think it wanted another touch. Constable said, "Then take it away with you that I may not be tempted to touch it again." ' He later painted another, more highly finished version, also in the Tate Gallery, which was engraved by David Lucas.

Salisbury Cathedral, from the Meadows, 1831

Oil on canvas, 151.8 × 189.9 cm. Private collection, on loan to the National Gallery, London

This painting, which was exhibited at the Royal Academy in 1831, is the most imposing of all Constable's Salisbury scenes, and the major project of his later years. He told C. R. Leslie that he thought it 'would probably in future be considered his greatest', since it conveyed 'the fullest impression of the compass of his art'. It seems that the work was begun in 1829, for in August of that year John Fisher, then Archdeacon of Salisbury, wrote to him, saying 'I am quite sure the "Church under a cloud" is the best subject you can take'. Fisher is referring, jokily, to the earlier picture of the Cathedral commissioned by his uncle, the Bishop (p. 101), who objected to Constable's habit of including a dark cloud in his compositions. By 1829, however, the cloud could serve Fisher as a metaphor for all those forces he and Constable believed were threatening the Anglican Church: the emancipation of Catholics, the threat to Church tithes and incomes, and the spectre of political reform.

But opposing the dark clouds and the lightning which strikes the church is the rainbow, foretelling the end of the storm and thus functioning as a traditional emblem of hope. The kinds of hope expressed, however, seem personal rather than political; Constable almost certainly knew that the direction and location of his rainbow were optically impossible, but he had more important considerations than scientific accuracy. The rainbow framing the cathedral, together with the cross on the spire accented against a break in the clouds, represent the Christian promise of salvation. The rainbow's end is located above John Fisher's house, Leydenhall, perhaps signifying the hopes that were sustained by their long friendship.

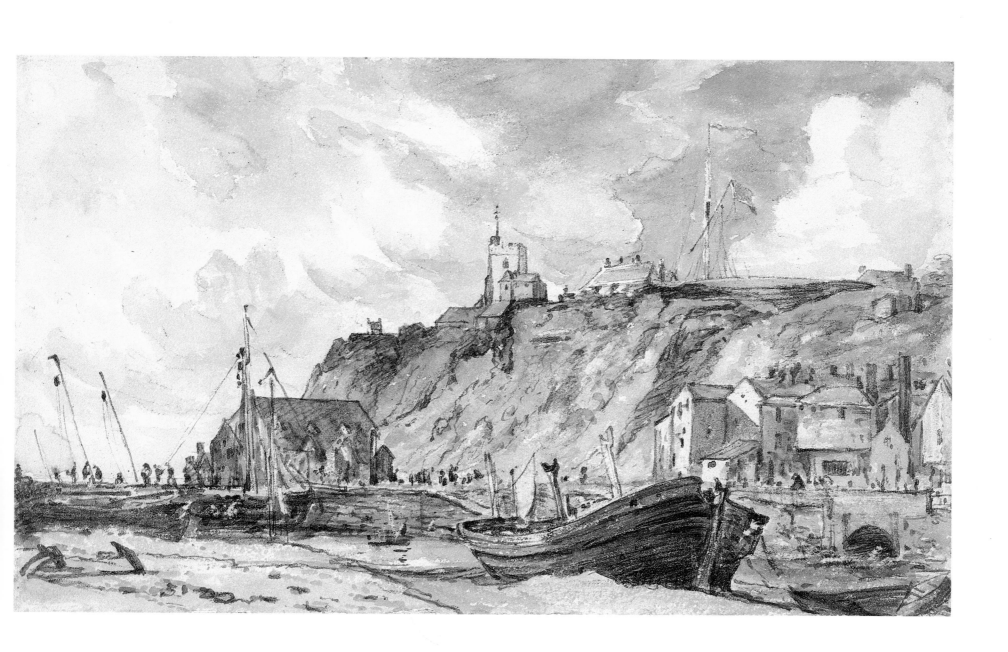

Whitehall Stairs, June 18th, 1817 (The Opening of Waterloo Bridge), 1832

Oil on canvas, 134.6 × 219.7 cm. Tate Gallery, London

Waterloo Bridge is unique within Constable's output, both for the length of time he took to complete it, and for the fact that it is an urban subject on the same grand scale as his Stour Valley 'six-footers'. Although he was in London when the bridge was opened, he did not begin to plan a painting of the subject until 1819. He then worked upon it intermittently until 1832, producing many preparatory sketches and drawings, but continually deferring its completion. Constable was in no doubt as to the importance of the painting, for he thought of showing a scaled-down version at the Royal Academy in 1824 'as a forerunner of the large one'. Equally there were times when he was depressed, anxious and discouraged about it: 'I have no inclination to pursue my Waterloo,' he said in July 1824, 'I am impressed with an idea that it will ruin me.' In spite of the encouragement he received from the Bishop of Salisbury, who declared it equal to Canaletto, he remained ambivalent about the work even whilst putting the finishing touches to the canvas. He wrote to David Lucas in February 1832, telling him 'I am dashing away at the great London – and why not? I may as well produce this abortion as another – for who cares for landscape?'

Constable's anxieties were revealed in a famous incident at the Royal Academy's 'varnishing days' – the period allotted for any final modifications to the pictures before the exhibition opened. The *Waterloo Bridge* was hung alongside Turner's *Helvoetsluys*, a muted sea-piece that was eclipsed by the strong reds of its neighbour. Turner responded, according to Leslie, by 'putting a round daub of red lead, somewhat bigger than a shilling, on his grey sea', which made the colours of the *Waterloo Bridge* seem pale by comparison. 'He has been here,' said Constable in dismay, 'and fired a gun.' The episode is sometimes cited as an instance of Turner's mean-mindedness, but such alterations were common during varnishing days and Turner sometimes made them in a playful spirit. Constable seems, in fact, to have over-reacted, particularly since Turner later glazed the *Helvoetsluys*, probably toning down the red lead in the process.

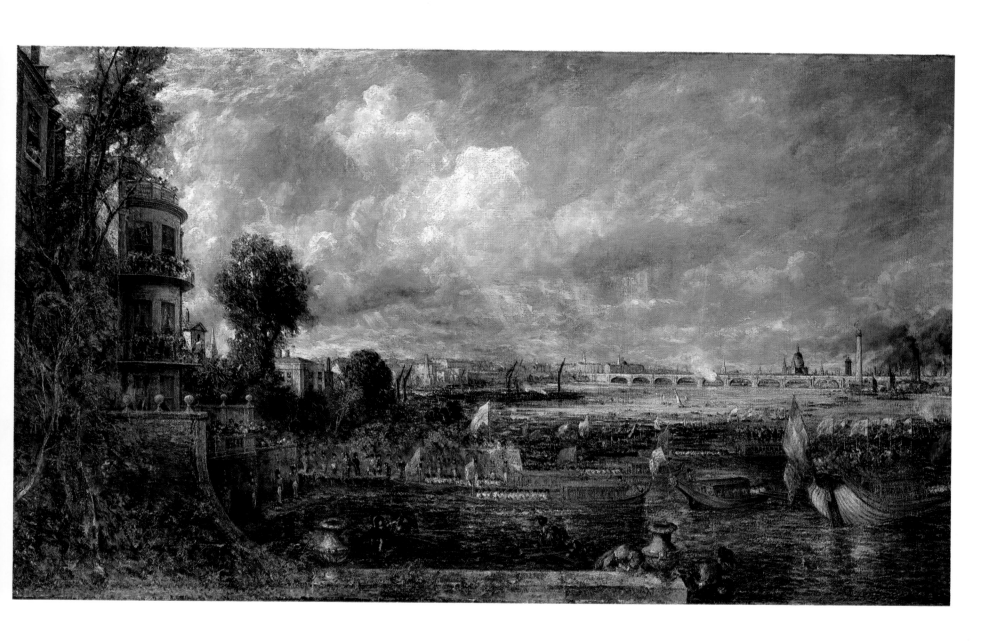

Trees and a Stretch of Water on the Stour, c. 1831–1836

Pencil and sepia wash, 20.3 × 16.2 cm. Victoria and Albert Museum, London

Constable executed a number of sepia drawings in the last years of his career, all of them notoriously difficult to date. This slight and rapid drawing of a Stour Valley subject was made upon one half of a sheet of writing paper; similarly, another example depicting the *Valley Farm* in the Fitzwilliam Museum, Cambridge, was painted on a scrap torn from a letter. In both cases the manner and the materials used suggest that they were produced spontaneously. Graham Reynolds suggested that this drawing and a companion in the Victoria and Albert Museum may have been made as an exercise in chiaroscuro, which was also Constable's main concern in supervising the collection of mezzotints after his works made by David Lucas.

250 SS

The Valley Farm, 1835

Oil on canvas, 147.3 × 125 cm. Tate Gallery, London

This was Constable's last major Stour Valley scene, and a return to a subject that had occupied him since at least 1802 – Willy Lott's cottage at Flatford. But when compared to earlier treatments such as the *Mill Stream* (p. 67) or *Hay-Wain* (p. 93) it is an idiosyncratic painting. Constable has wrought some disturbing changes, both to the cottage and its surroundings: the water looks choked and unmoving, a beggar is shown at the gate, and Lott's home is subjected to 'picturesque' decay, whereas in reality the family always kept it in a pristine condition. His grotesque amendments to the scene have been taken as a sign of his alienation from the motif and all it stood for; it is certainly a far cry from the 'natural painture' for which he strove in his early career.

In its present state the picture has a densely worked surface and a dark appearance that does not match the description he gave before the opening of the Royal Academy exhibition in 1835. 'I have got my picture in a very beautifull state,' he wrote, 'I have kept my brightness without my spottiness, and I have preserved God Almighty's daylight, which is enjoyed by all mankind.' The critics disagreed and took him to task for his handling: where Constable intended white highlights to signify the 'brightness' of reflected light, they saw only 'sleet and snow'. Perhaps in response to some of this criticism, he continued to work on the picture after the exhibition, even though it had already been purchased by the collector Robert Vernon for £300 – the highest price he ever received. Unfortunately, by 'Oiling out, making out, polishing, scraping &c', as he put it, he seems to have deprived it of its original freshness and it now appears laboured.

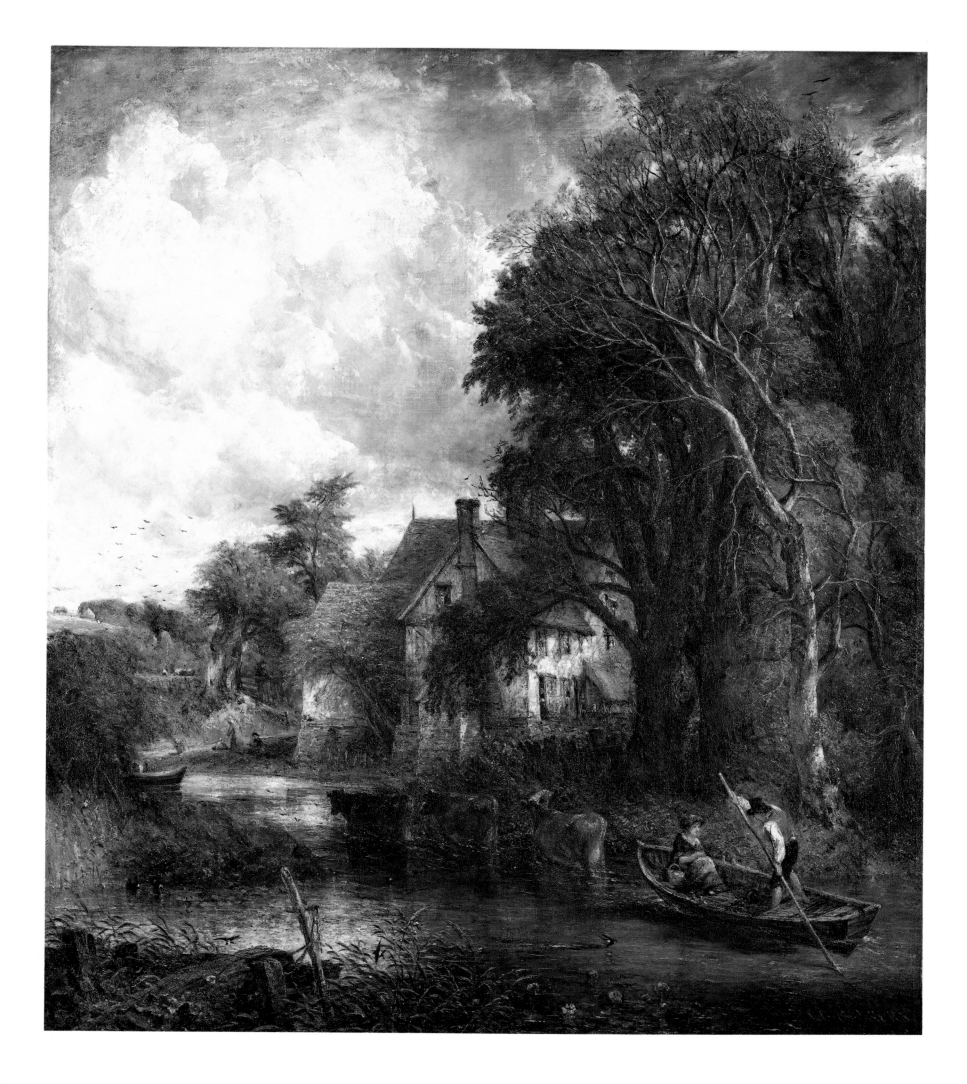

Cenotaph to the memory of Sir Joshua Reynolds, erected in the grounds of Coleorton Hall, Leicestershire, by the late Sir George Beaumont, Bart., 1833–1836

Oil on canvas, 132 × 108.5 cm. National Gallery, London

Constable was more than usually anxious to communicate his intentions in this painting, hence its long title and the publication in full in the Academy catalogue of the poem by Wordsworth inscribed on the monument. He laid aside work on *Arundel Mill and Castle* (p. 139) in order to finish *The Cenotaph* for the 1836 exhibition, the last to be held in the Academy's old premises in Somerset House. As he explained to his friend and namesake, George Constable, he wanted 'to see Sir Joshua Reynolds's name and Sir George Beaumont's once more in the catalogue, for the last time in the old house'. Like many artists of his generation, he was devoted to Reynolds's memory and example, whilst Beaumont had been a source of moral support during the early years of Constable's career. After a hiatus in their friendship Constable spent an extended period with Beaumont at Coleorton Hall in 1823, and it was during this stay that he sketched his host's memorial to Reynolds.

The oil painting makes important symbolic (and wholly imaginary) additions to the drawing in the sculptural busts of Raphael and Michelangelo, the two artists to whom Reynolds constantly appealed in his *Discourses* as the embodiment of the 'Grand Style' in art. Constable, who began his career with copies after Raphael, implies that their example played a formative role in developing the British School of painting to which he was proud to belong. The deer within the painting recalls the many instances on which Constable depicted *Jaques and the Wounded Stag*, a scene from Shakespeare's *As You Like It*. Beaumont entertained Constable during his visit in 1823 by reading from the play, perhaps having discovered that his guest was particularly fond of it. It may not be too fanciful, therefore, to see the deer in *The Cenotaph* as a private reference to Beaumont's friendship and hospitality.

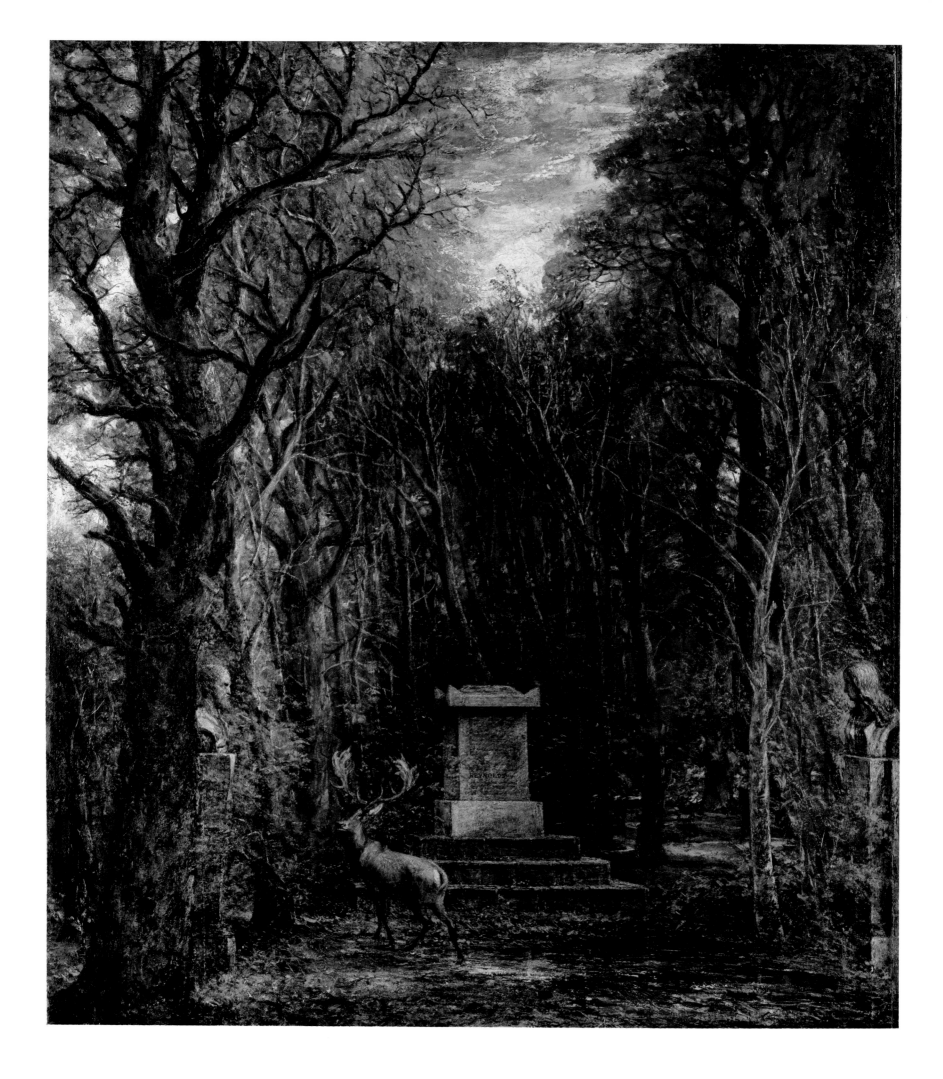

Arundel Mill and Castle, 1837

Oil on canvas, 72.4 × 100.3 cm. Toledo Museum of Art, Ohio

One of the closest friends of Constable's later years was the brewer, George Constable, who lived at Arundel. The painter visited him in 1834 and 1835 and was struck on both occasions by the Sussex scenery: 'The Castle is the chief ornament of this place,' he told Leslie, 'but all here sinks into insignificance in comparison with the woods, and hills. The woods hang from excessive steeps, and precipices, and the trees are beyond everything beautifull: I never saw such beauty in *natural landscape* before.' Constable gave his host an oil sketch of the mill and castle, but borrowed it in 1836 after his eldest son had persuaded him to prepare the subject for exhibition. He then shelved the painting in order to prepare *The Cenotaph* (p. 137) for the Academy instead, but resumed work on it the following year. He wrote to George Constable on 17 February 1837, telling him 'It is, and shall be, my best picture . . . It is safe for the exhibition as we have as much as six weeks good.' Constable always described his latest picture as his best, but *Arundel Mill and Castle*, if not his best, was his last, for exactly six weeks later, on 31 March, he died unexpectedly, leaving it unfinished. It was considered far enough advanced by Leslie and others to be shown posthumously at the Royal Academy.

The picture includes all those elements of the Arundel scenery he had described to Leslie, although in his correspondence Constable invariably refers to it simply as 'the Mill'. Leslie is surely right when he suggests that the presence of the Duke of Norfolk's mill brought with it associations and memories of the Stour Valley, thereby fixing the scene firmly in his affections.

CHRONOLOGY

1776
Born in East Bergholt, Suffolk, the fourth child of Ann and Golding Constable.

1783
Sent to school at Ford Street, Essex, thence to Lavenham and finally to Dedham Grammar School.

1793
Begins training as a miller. Paints in his spare time with John Dunthorne.

1795
Constable is introduced to Sir George Beaumont.

1796
Stays with relations at Edmonton where he meets J. T. 'Antiquity' Smith and John Cranch.

1798
Introduced to Dr John Fisher, later Bishop of Salisbury.

1799
Goes to London with a letter of introduction to Joseph Farington. Admitted as a probationer to the Royal Academy Schools.

1800
Copies works by Wilson, Ruysdael, Caracci and Claude.

1801
Tours and sketches in Derbyshire.

1802
Exhibits for the first time at the Royal Academy exhibition. Declines a post as a military drawing master.

1803
Journeys from London to Deal in the East Indiaman *Coutts*.

1804
Paints portraits of local Suffolk farmers. Sees Ruben's famous *Château de Steen* landscape in Benjamin West's studio.

1805
Commissioned to paint *Christ Blessing the Children* for Brantham church.

1806
Tours the Lake District, including Ambleside and Lake Windermere, Borrowdale and Langdale.

1807
Copies portraits by Reynolds and Hoppner for the Dysart family.

1808
Visits Dr Monro, patron of Cozens, Girtin, Turner and younger British artists. Becomes friendly with the celebrated genre-painter, David Wilkie.

1809
Spends August through to December in East Bergholt where he falls in love with Maria Bicknell.

1811
Meets the Revd John Fisher, who becomes his closest friend.

1812
Divides his time between London and Suffolk.

1813
Seated beside Turner at the Royal Academy dinner. July–October: fills a small sketchbook with pencil drawings from nature.

1814
Visits Southend and Hadleigh Castle. July: studies the Angerstein Claudes to improve his finishing.

1815
Death of his mother.

1816
Unrest in East Bergholt over the enclosure of the common. Death of Constable's father. August–September: at Wivenhoe Park, Essex. October: marries Maria Bicknell; they honeymoon with the Fishers at Osmington, Dorset.

1817
Summer: ten weeks at East Bergholt, his last long holiday in Suffolk. December: birth of his first child, John Charles.

1819
Finishes and exhibits *The White Horse*. July: birth of his second child, Maria Louise (Minna). Rents Albion Cottage, Upper Heath, Hampstead. November: elected Associate of the Royal Academy.

1820
Finishes and exhibits *Stratford Mill*.

1821
Exhibits *The Hay-Wain* at the Royal Academy. March: birth of his third child, Charles Golding. Studies the skies intensively.

1822
Serious agrarian unrest in Suffolk. The *View on the Stour near Dedham* exhibited at the Royal Academy. August: birth of Isabel Constable.

1823
October–November: with Sir George Beaumont at Coleorton Hall, Leicestershire.

1824
May–November: his family at Brighton for Maria's health; Constable joins them intermittently. *The Hay-Wain*, *View on the Stour near Dedham* and *View of Hampstead* are shown at the Paris Salon. King Charles X awards him a Gold Medal.

1825
March: birth of Emily Constable. May: *The Leaping Horse* well received at the Royal Academy. Becomes increasingly friendly with C. R. Leslie, his future biographer.

1827

Death of Sir George Beaumont. Settles permanently into 6, Well Walk, Hampstead. September: sends *The Cornfield* to the Paris Salon.

1828

Birth of Lionel Bicknell Constable. November: Maria Constable dies of pulmonary tuberculosis.

1829

Elected Royal Academician. David Lucas begins mezzotints after Constable's works to be published as *English Landscape*.

1830

Water-Meadows near Salisbury appears incognito before the selectors of the Royal Academy exhibition and is rejected.

1831

January: instructs Royal Academy students in drawing from the model. Begins work upon *Salisbury Cathedral, from the Meadows*. Suffers from acute rheumatism.

1832

Completes and exhibits *Waterloo Bridge*. August: death of John Fisher.

1833

Lectures to Hampstead Literary and Scientific Society.

1834

February: suffers rheumatic fever. July: visits George Constable at Arundel. September: a guest of the Earl of Egremont at Petworth.

1835

Lectures again at Hampstead and Worcester. July: at Arundel with George Constable.

1836

The Cenotaph is exhibited at the Royal Academy. Lectures on Landscape to the Royal Institution and at Hampstead.

1837

February: at work on *Arundel Mill and Castle*. 31 March: dies, possibly of a heart attack. Buried at Hampstead Parish Church.

SELECTED BIBLIOGRAPHY

BARRELL, J., *The Dark Side of the Landscape*, Cambridge, 1980.

BECKETT, R. B. (ed.), *John Constable's Correspondence*, vols. 1–6, Ipswich, 1962–8.

CORMACK, M., *Constable*, London, 1986.

FLEMING WILLIAMS, I., and PARRIS, L. (eds.), *John Constable: Further Documents and Correspondence*, London and Ipswich, 1975.

LESLIE, C. R., *Memoirs of the Life of John Constable R. A.*, London, 1843; 2nd edn. (revised), London, 1845.

GADNEY, R., *Constable and his World*, London, 1976.

PARRIS, L., *Landscape in Britain c1750–1850*, London, 1973.

REYNOLDS, G., *Constable the Natural Painter*, London, 1966.

—— *Catalogue of the Constable Collection in the Victoria and Albert Museum*, 2nd edn., London, 1972.

—— *The later Paintings and Drawings of John Constable*, 2 vols., New Haven and London, 1984.

REDGRAVE, S. & R., *A Century of British Painters*, 1866; new edn., London, 1947.

ROSENTHAL, M., *Constable, the Painter and his Landscape*, New Haven and London, 1983.

SHIRLEY, A., *The Published Mezzotints of D. Lucas after John Constable R. A.*, Oxford, 1930.

WHITLEY, W. T., *Art in England 1800–1837*, 2 vols., London, 1932.

LIST OF PLATES

Frontispiece: Map showing Dedham, Flatford and East Bergholt.

7: John Constable, *View at East Bergholt over the Gardens at Golding Constable's House*, c. 1814, pencil, 30.2 × 44.9 cm. Victoria and Albert Museum, London.

8: John Constable, *Incised Outline of a Windmill*, a fragment of the windmill on East Bergholt Heath, 1792, incised in wood, 29.5 × 39.5 cm. The Minories, Colchester.

10: Thomas Gainsborough, *Cornard Wood*. 1748, oil on canvas, 121.9 × 154.9 cm. National Gallery, London.

11: John Hoppner, *Portrait of Sir George Beaumont*, 1806, oil on canvas, 77.5 × 63.9 cm. National Gallery, London.

12: Claude Lorraine, *Landscape with Hagar and the Angel*. c. 1646, oil on canvas, 52.7 × 43.8 cm. National Gallery, London.

13: Claude Lorraine, *Landscape with a Goatherd and Goats*, 1637, oil on canvas, 51.5 × 41.3 cm. National Gallery, London.

15: John Constable, *Winter: A Copy after Jacob van Ruysdael*, 1832, oil on canvas, 58.1 × 70.8 cm. Private collection.

16: Sir Joshua Reynolds, *Self-portrait in his Robes as a Doctor of Civil Law of Oxford University*, 1773–80, oil on canvas, 127 × 101.6 cm. Royal Academy of Arts, London.

22: John Constable, *Portrait of the Rev. John Fisher*, 1817, oil on canvas, 35 × 29.7 cm. Fitzwilliam Museum, Cambridge.

23: John Constable, *Christ Blessing the Children*, c. 1805, oil on canvas, 213.4 × 127 cm. St Michael's Church, Brantham.

25: John Constable, *Portrait of Maria Bicknell, Mrs John Constable*, 1816, oil on canvas, 30.1 × 25.1 cm. Tate Gallery, London.

27: (*top*): J. M. W. Turner, *Frosty Morning*, 1813, oil on canvas, 114 × 175 cm. The Charles Clore Gallery for the Turner Bequest, London.

27: (*bottom*): Peter de Wint, *A Cornfield*, c. 1815, oil on canvas, 103.1 × 161.3 cm. Victoria and Albert Museum, London.

28: John Constable, Pages from a sketchbook used in 1813, 8.9 × 12 cm. Victoria and Albert Museum, London.

33: Photograph of Willy Lott's cottage, Flatford.

38: Mezzotint by David Lucas after John Constable, *The Paternal House and Grounds of the Artist*, 1829, engraved on steel, 42.8 × 29 cm. Victoria and Albert Museum, London.

40: Daniel Maclise, pencil sketch of Constable painting, c. 1831, 15 × 11.5 cm. National Portrait Gallery, London.

42: Lionel Bicknell Constable, *Near Stoke by Nayland*, c. 1850, oil on canvas, 35.6 × 44.5 cm. Tate Gallery, London.

45: *Dedham Church and Vale*, 1800, pen, ink and watercolour, 34.6 × 52.7 cm. Whitworth Art Gallery, University of Manchester.

47: *Dedham Vale*, 1802, oil on canvas, 43.5 × 34.4 cm. Victoria and Albert Museum, London.

49: *Warehouses and Shipping on the Orwell at Ipswich*, 1803, watercolour and pencil, 24.5 × 33.1 cm. Victoria and Albert Museum, London.

51: '*His Majesty's Ship "Victory", Capt. E. Harvey, in the memorable Battle of Trafalgar between two French Ships of the Line*', 1806, watercolour, 51.6 × 73.5 cm. Victoria and Albert Museum, London.

53: *Windermere*, 1806, pencil and watercolour, 20.2 × 37.8 cm. Fitzwilliam Museum, Cambridge.

55: '*A church porch' (The Church Porch, East Bergholt)*, c. 1809, oil on canvas, 44.5 × 35.9 cm. Tate Gallery, London.

57: *Flatford Mill from the Lock*, c. 1811, oil on canvas, 24.8 × 29.8 cm. Victoria and Albert Museum, London.

59: *East Bergholt Church*, 1811, watercolour, 39.7 × 60 cm. The Lady Lever Art Gallery, Port Sunlight.

61: *Study for Stratford Mill*, 1811, oil on wood, 18.3 × 14.5 cm. Private collection.

63: *Dedham Vale: Morning*, 1811, oil on canvas, 78.8 × 129.5 cm. Private collection.

65: *Landscape: Boys Fishing*, 1813, oil on canvas, 101.6 × 125.8 cm. National Trust, Fairhaven Collection, Anglesea Abbey.

67: *The Mill Stream*, c. 1814, oil on canvas, 71.1 × 91.5 cm. Ipswich, Museums and Galleries.

69: *Landscape: Ploughing Scene in Suffolk (A Summerland)*, 1814, oil on canvas, 51.4 × 76.8 cm. Private collection.

71: *View of Dedham*, 1814, oil on canvas, 55.3 × 78.1 cm. Museum of Fine Arts, Boston, Massachusetts.

73: *Boatbuilding*, 1814, oil on canvas, 50.8 × 61.6 cm. Victoria and Albert Museum, London.

75: *Golding Constable's Flower Garden*, 1815, oil on canvas, 33 × 50.8 cm. Ipswich, Museums and Galleries.

77: *Golding Constable's Kitchen Garden*, 1815, oil on canvas, 33 × 50.8 cm. Ipswich, Museums and Galleries.

79: *Wivenhoe Park*, 1816, oil on canvas, 56.1 × 101.2 cm. Widener Collection, National Gallery of Art, Washington, DC.

81: *Weymouth Bay*, c. 1816, oil on canvas, 52.7 × 74.9 cm. National Gallery, London.

83: *Flatford Mill*, 1817, oil on canvas, 101.7 × 127 cm. Tate Gallery, London.

85: *The White Horse*, 1819, oil on canvas, 131.5 × 187.8 cm. Frick Collection, New York.

87: *Branch Hill Pond, Hampstead*, 1819, oil on canvas, 25.4 × 30 cm. Victoria and Albert Museum, London.

89: *Hampstead Heath*, c. 1820, oil on canvas, 54 × 76.9 cm. Fitzwilliam Museum, Cambridge.

91: *Harwich Light-House*, c. 1820, oil on canvas, 32.7 × 50.2 cm. Tate Gallery, London.

93: *Landscape: Noon (The Hay-Wain)*, 1821, oil on canvas, 130.5 × 185.5 cm. National Gallery, London.

95: *Cloud Study*, 1821, oil on paper on board, 24.7 × 30.2 cm. Paul Mellon Collection, Yale Center for British Art, New Haven.

97: *Study of Cirrus Clouds*, 1822, oil on paper, 11.4 × 17.8 cm. Victoria and Albert Museum, London.

99: *Landscape with Goatherd and Goats* (copy after Claude), *c.* 1823, oil on canvas, 53.3 × 44.5 cm. Art Gallery of New South Wales, Sydney.

101: *Salisbury Cathedral, from the Bishop's Grounds*, 1823, oil on canvas, 87.6 × 111.8 cm. Victoria and Albert Museum, London.

103: *The Lock (A Boat Passing a Lock)*, 1824, oil on canvas, 142.2 × 120.7 cm. Walter Morrison Collection, Sudeley Castle.

105: *Brighton Beach with Colliers*, 1824, oil on paper, 14.9 × 24.8 cm. Victoria and Albert Museum, London.

107: *Full-size Sketch for 'The Leaping Horse'*, 1824–5, oil on canvas, 129.4 × 188 cm. Victoria and Albert Museum, London.

109: *The Leaping Horse*, 1824–5, oil on canvas, 142.2 × 187.3 cm. Royal Academy of Arts, London.

111: *A Mill at Gillingham in Dorset (Parham's Mill)*, 1826, oil on canvas, 50.2 × 60.3 cm. Yale Center for British Art, New Haven.

113: *The Cornfield*, 1826, oil on canvas, 143 × 122 cm. National Gallery, London.

115: *The Chain Pier, Brighton*, 1827, oil on canvas, 127 × 183 cm. Tate Gallery, London.

117: *Dedham Vale*, 1823, oil on canvas, 145.2 × 121.9 cm. National Galleries of Scotland, Edinburgh.

119: *Full-size Sketch for Hadleigh Castle*, *c.* 1828–9, oil on canvas, 122.5 × 167.5 cm. Tate Gallery, London.

121: *Old Sarum*, 1829, oil on card, 14.3 × 21 cm. Victoria and Albert Museum, London.

123: *Landscape: A Study (Water-Meadows near Salisbury)*, 1829, oil on canvas, 45.7 × 55.3 cm. Victoria and Albert Museum, London.

125: *The Glebe Farm*, *c.* 1830, oil on canvas, 65.1 × 95.6 cm. Tate Gallery, London.

127: *Salisbury Cathedral, from the Meadows*, 1831, oil on canvas, 151.8 × 189.9 cm. Private collection, on loan to the National Gallery, London.

129: *Folkestone: The Harbour*, 1833, watercolour and pencil, 12.7 × 21.6 cm. Fitzwilliam Museum, Cambridge.

131: *Whitehall Stairs, June 18th, 1817 (The Opening of Waterloo Bridge)*, 1832, oil on canvas, 134.6 × 219.7 cm. Tate Gallery, London.

133: *Trees and a Stretch of Water on the Stour*, *c.* 1831–6, pencil and sepia wash, 20.3 × 16.2 cm. Victoria and Albert Museum, London.

135: *The Valley Farm*, 1835, oil on canvas, 147.3 × 125 cm. Tate Gallery, London.

137: *Cenotaph to the memory of Sir Joshua Reynolds, erected in the grounds of Coleorton Hall, Leicestershire, by the late Sir George Beaumont, Bart.*, 1833–6, oil on canvas, 132 × 108.5 cm. National Gallery, London.

139: *Arundel Mill and Castle*, 1837, oil on canvas, 72.4 × 100.3 cm. Toldeo Museum of Art, Ohio.